Pembrokeshire
another year, another day

Pembrokeshire

another year, another day

Logaston Press

LOGASTON PRESS
Little Logaston Woonton Almeley
Herefordshire HR3 6QH
www.logastonpress.co.uk

First published by Logaston Press 2010

ISBN (paperback) 978 1 906663 34 6
ISBN (hardback) 978 1 906663 33 9

This is number of the limited hardback edition of 500 copies

Typeset by Logaston Press
and printed and bound in Poland
www.polskabook.pl

Rear cover photograph: Autumn swell (Adrian Hawke)

Map showing the locations of the images, the numbers equating to the page on which the image occurs

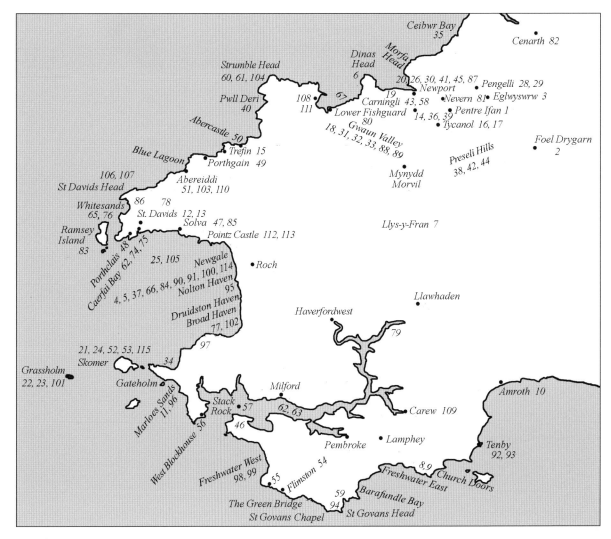

Ceibwr Bay
35

Cenarth 82

Dinas
Head
6

Morfa Head

Strumble Head
60, 61, 104

20, 26, 30, 41, 45, 87
Newport
Pengelli 28, 29

Pwll Deri
40

108
111

67

19
Carningli 43, 58
Nevern 81
Eglwyswrw 3

Lower Fishguard
80

14, 36, 39
Pentre Ifan 1

Abercastle 50

Gwaun Valley
18, 31, 32, 33, 88, 89

Tycanol 16, 17

Foel Drygarn
2

Blue Lagoon

Trefin 15
Porthgain 49

Mynydd
Morvil

Preseli Hills
38, 42, 44

106, 107
St Davids Head

Abereiddi
51, 103, 110

Whitesands
65, 76

86
78

St. Davids 12, 13

Solva 47, 85

Llys-y-Fran 7

Ramsey
Island
83

Pointz Castle 112, 113

Porthclais 48

25, 105

Newgale

Roch

Llawhaden

Caerfai Bay 62, 74, 75

4, 5, 37, 66, 84, 90, 91, 100, 114

Nolton Haven
95

Haverfordwest

79

Druidston Haven
Broad Haven
77, 102

97

21, 24, 52, 53, 115
Skomer

34

Grassholm
22, 23, 101

Gateholm

Milford

Amroth 10

Marloes Sands
11, 96

Stack
Rock
57

62, 63

Carew 109

46

Lamphey

West Blockhouse 56

Pembroke

Tenby
92, 93

Freshwater West
98, 99

55
Flimston 54

8, 9
Freshwater East

Church Doors

59
94
Barafundle Bay

The Green Bridge
St Govans Chapel

St Govans Head

Preface & Acknowledgements

In 2007 we published *Pembrokeshire: a year and a day*, a selection of the work of a number of local photographers. This second volume, which is to a larger format and on heavier paper, adopts the same style, the photographs being arranged so that they broadly run from early morning in winter through the soft light of spring, the stronger light of summer and the varied colours of autumn, to conclude with a series of winter sunsets: 'another year, another day'.

The introduction, compiled from material supplied by the photographers, does not attempt to give a comprehensive history and guide to Pembrokeshire — which would be impossible in so few pages in any event — but gives some background to the subjects of the photographs: the history of Pembrokeshire's harbours, the geology of the rocks that form the Pembrokeshire coastline, the origins of the hillforts that are featured and the natural history of the marine nature reserve, for example.

The publisher would like to thank all the photographers for their unfailing helpfulness; it has been a real pleasure to work with them. Many thanks to them for supplying the images requested, and also for giving thought to the information to be included in the captions and the introduction.

Introduction

Pembrokeshire's cliffs and bays, shores and islands, its harbours and ports, its flower-studded woodlands and open hillsides, its many prehistoric cairns and chambered tombs, its castles and industrial past provide a rich variety of subjects for the art of photography. These few pages give a little historical background to the photographs that follow.

Early history

At the end of the last Ice Age, some 12,000 years ago, sea level would have been about 100m lower than it is today. Late Palaeolithic man would have sheltered in caves at the base of the present cliffs from where they would have hunted the like of woolly mammoth on what is now the seabed. From around 10,000 years ago the climate started to warm and as it did so the prey that humans hunted changed, woolly mammoth and cave bear giving way to reindeer and horse. Man also became more of a 'gatherer', and nuts and berries became a greater part of the diet of Mesolithic (or middle stone age) people. Flint was a valuable commodity at this time though a rare one in Pembrokeshire. Working this precious resource was a skilled business, and scrapers, borers, arrowheads and spear points were all manufactured in a limited number of 'flint factories'. On the Dale peninsula near Castlebeach it is possible to find examples of worked flint from this period on the coastal footpath.

Around 5,000 years ago the practice of agriculture was adopted in Pembrokeshire, having spread from the Middle East. Until then people had been essentially nomadic hunter-gatherers, but with the advent of farming, lifestyles changed completely. Houses (hut circles) were built, and livestock were domesticated and their movements controlled with the erection of stone field boundaries. Perhaps the most famous relics from this new Stone Age (Neolithic) period are the burial chambers that still grace the landscape, built for the communal burial of the dead, not just chieftains and kings. At Pentre Ifan the capstone weighs an estimated 16 tons and is aligned exactly along a north/south axis. When covered with earth, as it would have been, the monument would have appeared even larger than it does today. These megalithic (big-stone) structures are contemporary with the most famous of them all, Stonehenge, and indeed the links are more than just temporal, as spotted dolerite from Carn Menyn in the Preselis was used in the second phase of Stonehenge's construction.

Remains of the subsequent Bronze Age in Pembrokeshire are less obvious. Beaker Folk (makers of finely decorated urns) set out from Whitesands Bay for trade routes with Ireland from about 3,500 years ago. It was about this time that people first cremated their dead, burying the ashes in small cairns. The following Iron Age was accompanied by an increase in population

that put pressure on local resources and heightened the possibility of conflict. As a result the most obvious Iron Age remains are fortifications, in the main formed by cutting ditches and creating banks encircling hilltops and, in Pembrokeshire, across narrow cliff-top promontories. The hillfort on Foel Drygarn has been shown to have been crowded with well over 200 house-sites, perhaps as a result of it long being a centre of population: its summit is crowned by three massive stone cairns used to bury the dead in the preceding Early Bronze Age, and there are indications that the settlement may date back to the Neolithic some 6,000 years ago. Recent Royal Commission ground surveys of some of the coastal 'promontory forts' suggest that many may in fact not have been settlements at all, but instead places for seasonal meetings or religious ceremonies.

Skomer Island has one of the best preserved prehistoric farming landscapes in Britain. It is thought that the island was settled for several generations in the Iron Age, or perhaps even earlier in prehistory, leaving a legacy of field terraces, stone field walls and the footings of roundhouses. The end of the Iron Age is defined by the arrival of the Romans. Carmarthen seems to be the westernmost settlement substantiated by evidence; rumour suggests a settlement at Whitesands (called *Manapia*) but it has not been found.

When the Roman legions left Britain in 410 AD, Pembrokeshire entered not so much the Dark Ages but the Age of the Saints. No one has yet authoritatively dated the arrival of the Christian message in Pembrokeshire, but as the area was essentially untouched by Rome, it is most likely to have arrived from Ireland or Brittany, the sea then being the main thoroughfare, as indeed it was until quite recently. From about 400AD onwards the St.

Davids peninsula was a focus for early Christian activity. St. David himself, the son of St. Non, was born *c.*520 and when an adult established a harshly ascetic community in the place that subsequently took his name. Nobody really knows who St. Govan was but the most popular idea is that he was Sir Gawaine, of round table fame, who turned hermit after the death of King Arthur.

In the 8th, 9th and 10th centuries Viking raiders sacked the coastline of Pembrokeshire many times. They must have seen St. Davids as a particular source of spoil, for despite its being hidden in a dip they found it eight times in as many decades. However other Vikings appear to have settled along the Milford Haven waterway, which suggests a more peaceful relationship.

The Normans arrived in Pembrokeshire by 1090. They took for themselves the rich farmland in the southern half of Pembrokeshire based on a new lordship at Pembroke, and a defensive screen of castles was built from Roch through Llawhaden, Narberth, Carew and Tenby to Amroth to keep the Welsh to the north at bay. At Carew the Norman castle was later altered to form an Elizabethan residence. Perhaps its most famous owner was Sir Rhys ap Thomas, who was made Governor of Wales by Henry VII and became renowned for staging the last great Welsh Tournament, lasting five days, at Carew in 1507.

St. Davids flourished after the Norman arrival, and as a result has the longest continuous story of any religious settlement in the UK at over 1,400 years. Chapels existed from early on but building on a large scale began in 1178 under Bishop Peter de Leia, continuing for the next 300 years to give the basic structure seen today. From 1328 Bishop Gower extensively remodelled and extended the buildings, and in 1509 Bishop Vaughan added a third tier to the tower. Henry VIII's time saw the buildings fall

into a state of disrepair. John Nash restored the west front in 1793 (to a rather unenthusiastic reception). In 1862, the gothic revivalist, George Gilbert Scott, effectively saved the cathedral with a massive renovation project, which he viewed as one of his greatest achievements. In recent years a new cloister has been installed and represents an important addition to this historic building.

The Coast

Starting in the far north-east of the county, and heading south-west along the coast, Newport is the first major inlet reached. By the mid 1500s the town was trading with ports up the Bristol Channel exporting wool and slate, and importing coal and limestone. At the same time herring was being exported to Ireland, France and Spain. Newport, along with Fishguard and Lawrenny, soon boasted a proper shipyard, but there were 30 or so other small scale boat-building sites around the coast. By the end of the 19th century it was a thriving port with warehouses, limekilns, coal and shipyards all prospering. Today the silted-up harbour is a popular scenic spot, as are many of the county's other harbours.

At one time many of these harbours would have had floating village shops, ships from Bristol arriving to sell goods before heading back up the Bristol Channel to restock. Larger vessels made it to places as far afield as Newfoundland (for building timber), Chile (for phosphates/guano) and Morocco (for corn). Coastal villages in Pembrokeshire were in more direct and constant contact with each other than they were with their respective hinterlands. But the railway changed everything. Trade routes shifted away from the coast and the subsequent advent of metalled roads and lorries killed many coastal villages

stone dead. A tradition dating back to the Neolithic had run its course and coastal Pembrokeshire became isolated. However, Goodwick to the west of Newport remains an active port. Once a staging post for trans-Atlantic liners (including the *Lusitania*), it now caters for ferries travelling to Rosslare in Ireland. And Milford Haven is still one of the UK's major ports.

But coastal Pembrokeshire is not all about ports. Some miles to the west of Goodwick, Garn Fawr affords 360° panoramic views that include coastal Pembrokeshire and its surprisingly flat hinterland, the latter the result of sub-marine erosion some 20 million years ago, with the present clifftops once an ancient sea floor. The landmarks that stand proud above this rock platform are erosion resistant rocks (mainly volcanic in origin) such as the Preseli hills, Carn Llidi by Whitesands Bay and Penberry by St. Davids, together with Garn Fawr itself.

Porthgain was once another prosperous industrial harbour in the early 1900s, serving the nearby Abereiddi slate quarry, which operated from about 1830 to 1904. This produced rather poor quality slates which were taken by tramway to Porthgain for shipment. When quarrying ceased, an opening to the sea was created and the area was flooded to create the present day Blue Lagoon. Further west and south, near St. Davids, Ramsey Island lies one mile offshore and is now an RSPB nature reserve, famous for its seabirds, seals and cliffs up to 120 metres in height.

Solva is soon reached when heading eastwards along the coast from St. Davids. A port since the 1300s, Solva had the advantage over its neighbour, Porthclais, in that it was deeper and able to accommodate ships of up to 300 tons. Solva's importance grew in the 18th century with cargoes of coal, wood, grain, butter and woven goods destined for Wexford, Bristol and further afield.

The port was also the main lime-burning centre for the St. Davids peninsula, boasting ten working kilns in Victorian times, many of which are still visible on the east side of the harbour. The main street, now a colourful haven for visitors, would have been a pretty messy affair with warehouses, mills, stables, blacksmiths, wheelwrights, carpenters, saddlers and weavers all jostling for trade. Its maritime tradition is reflected to this day in the many boats and yachts moored on the sands below the village. The river mouth is overlooked by Solva Head promontory fort, an Iron Age settlement, and two more overlook it from further up the hillslope; a Roman brooch was also found here.

A few miles further on the sweeping bay of Newgale is reached, popular with photographers in this book, and also with surfers, beachcombers and horseriders. Beyond Newgale, the section of coast between Druidston and Broad Haven is formed from rock that is loosely held together, and changes occur every year as storm waves batter the cliffs. Broad Haven itself is an increasingly popular place to visit, but little is known of its history before the 1800s, and there are no signs of any early settlements. The prime industry here was coal, which was taken from the pits on the cliffs and sent mainly to north Wales.

To the south-west of Broad Haven, Skomer Island is a National Nature Reserve and internationally famous for its breeding populations of manx shearwaters (40% of the world's total), puffins, guillemots, razorbills, kittiwakes and various other marine and terrestrial species of bird. Atlantic grey seals breed around the island in the autumn. The sea surrounding Skomer is rich in unusual species and communities of animals and 'plants'; as a result the area is designated a Marine Nature Reserve and, at present, is Wales' only one. Grassholm, some eight miles west of Skomer, is owned by the RSPB and is home to approximately 32,000 pairs of gannets (some 10% of the world's total). Grassholm, along with Ramsey, Skomer and Skokholm, was designated as a Specially Protected Area (SPA) in response to the Earth Summit held in Rio de Janeiro in 1992 and is part of Europe's network of sites to conserve biodiversity.

Back on the mainland, Marloes Sands is a large isolated bay sitting between the headlands of Gateholm Stack (off which lies Gateholm Island) and Hooper's Point that has spectacular geological features as well as attracting fossil hunters.

Beyond Marloes Sands lies Dale and the entrance to the Milford Haven waterway. During the 19th century substantial investment in the new towns of Milford, Neyland and Pembroke Dock meant that the Haven became a harbour of great strategic importance; consequently, plans were put forward to fortify the waterway properly for the first time. Initially attention was focused around the Royal Naval Dockyard at Pembroke Dock (reckoned during its heyday in the 19th century to be the most advanced shipyard in the world), but fortifications soon spread seaward until in total the defences could accommodate 1,900 men and 220 heavy guns.

Milford Haven's history is one of a series of false starts. It started out at the end of the 18th century as a whaling station for Quakers reverse-migrating from Nantucket, but that proved unsuccessful. It was nearly a great trans-Atlantic terminus. It was nearly a world-class naval dockyard. It was nearly a great fishing port; indeed it was once possible to walk from one side of the docks to the other on the decks of the local fishing fleet.

In Milford's ultimate favour, though, was the fact that it was a natural deep-water harbour. When the oil industry was looking

for a port to accommodate 100,000-ton tankers, Milford seemed the obvious choice. Esso built the first oil refinery in 1958 and BP added a storage facility on the opposite shore. Texaco, Gulf and Amoco followed suit, but the promise for local employment was never realised as fully as hoped, the companies bringing a lot of their own trained personnel with them. Now Esso and BP have gone. Many of the other companies have changed their names or indeed their products. The most recent development is the storage of Liquefied Natural Gas at the former Gulf site.

On the southern side of the entrance to Milford Haven, some of the best examples of coastal cliff forms occur around St. Govan's Head. The rocks have produced features such as the Green Bridge of Wales, Elegug Stacks and Huntsman's Leap. St. Govan's Chapel is found at the base of the cliffs. Just a short way further east lies Stackpole Warren, a landscape famed among archaeologists for preserving prehistoric settlements and ritual monuments — particularly standing stones.

Further east still, as the coastal path heads towards Tenby, the stretch of coast between Lydstep and Skrinkle Haven is formed from Carboniferous Limestone and is approximately 300 million years old. The rocks started life as limestone-rich deposits (derived at least in part from the shells of the animals living in the sea at the time) under a shallow tropical ocean, teeming with life forms commonly associated with modern day coral reefs, and subsequent mountain building episodes in the Earth's history have tilted some of these rocks 90° to the horizontal plane. Nearby Caldey Island has a mixed geology, part Carboniferous Limestone in common with much of south-east Pembrokeshire, and part Old Red Sandstone, which is more common in the area around the Dale peninsula. Extensive folding and faulting of the landscape approximately 280 million years ago has led to complex intermingling of these two differently aged rock types. Caldey is now home to Trappist Cistercian monks whose order arrived from Belgium in 1929.

Flora and Fauna

Because the county is host to many rock types there are also many different types of soil, which in turn favours floral diversity. Apart from the clifftops there are sand dunes, salt marshes, meadows, woodlands, freshwater marshes, bogs, river banks and coastal heath to name a few. Exposure to salt-laden wind means that bluebells on Skomer often flower two to three weeks later than their mainland counterparts, whilst thrift on salt marshes flowers after its coastal cousin by a similar margin. Such exposure can also change the appearance and size of some plants so much that it can be difficult to recognize the same species in different locations.

Perhaps the most impressive faunal display is in the colonies of seabirds on the offshore islands and rock stacks. Puffins, guillemots and razorbills represent the auk family. Fulmars are relatively recent visitors having bred in Pembrokeshire only since 1949. One of the UK's rarest birds, the manx shearwater, breeds here; Skomer and Skokholm islands may host something approaching 50% of the world's population. Inevitably there are gulls: herring, lesser and great black-backed. Kittiwakes feed on plankton and surface fish and spend most of their life on or over the ocean. Then there are gannets, whose 180cm wingspan is the largest of any British seabird. Gannets plunge-diving for fish are a sight to behold.

Pembrokeshire's Atlantic grey seals number approximately 5,000 individuals, the largest population in southern Britain.

They are resident all year round to a varying degree (in contrast to the seabird populations which are mostly gone by August, gannets excepting) and they have their pups in the autumn.

Beaches are another gem in Pembrokeshire's treasure chest. There are rocks, pools, sand patterns, plants and a host of animals to observe.

Below the low tide mark Pembrokeshire continues to be beautiful and interesting due to the high diversity of habitats available. About a third of all types of seaweeds that occur in the UK can be found in the Skomer Marine Reserve, as it contains a mixture of both Mediterranean/Atlantic species at their northern distributional limit and northern species at their southernmost limits. In addition, over 850 species of marine invertebrates have been found buried in the sediments around Skomer alone. Nearly 100 species of sponge and 67 species of sea slug have been recorded.

But within Pembrokeshire there are many areas that do not depend upon the coast and the sea for their beauty. The National Nature Reserve of Tycanol, on the northern slopes of the Preseli Hills, comprises gnarled oaks over 800 years old and rocky outcrops covered with moss and some 400 species specious of lichen. Further west, the Gwaun Valley runs some 8 miles from the Preseli hills towards Fishguard. Originally thought to have been carved out by water that overflowed from glacial meltwater lakes around the Nevern region of north Pembrokeshire at the end of the last ice age, when the valley floor was inspected carefully it was found that at times water must have flowed uphill. As this can only happen when water is under pressure, it is now thought that the valley was carved as a sub-glacial meltwater channel: as glaciers flowed through the Gwaun Valley and its offshoots, meltwater at the base of the ice, under tremendous pressure, was forced back up the slope.

Other woodlands include Minwear on the Cleddau which consists of mixed woodland, the ancient trees near Blackpool Mill sustaining many types of fauna and wildlife. Another important ancient woodland, Pengelli Wood in the north of the county, is managed by the West Wales Wildlife Trust, and there is also Llys-y-Fran country park north-east of Haverfordwest.

Photographic lighting

Photography literally means writing with light and, all other things being equal, the better the pen (quality of light) the better the essay (photograph). Landscape photographers often talk about the golden two hours after sunrise and similarly before sunset. Some photographers go as far as to say never use a camera after 10am and before 4pm. There is no doubt that the quality of light can be at its best at the edges of the day but there are (as with all photographic rules) exceptions. Winter days may be good throughout as the sun is permanently low in the sky. Strong daylight in the summer may favour bold, simple compositions with rich coloration. Misty days, days with high, thin cloud and even rainy days all have merit for different photographic themes. Shooting with the light behind, and slightly to one side of, the camera favours many subjects, but picture taking straight into the sun can yield spectacular, dramatic, different results. The photographers in this collection have experimented with many approaches, though they inevitably favour the special magic of the golden hours.

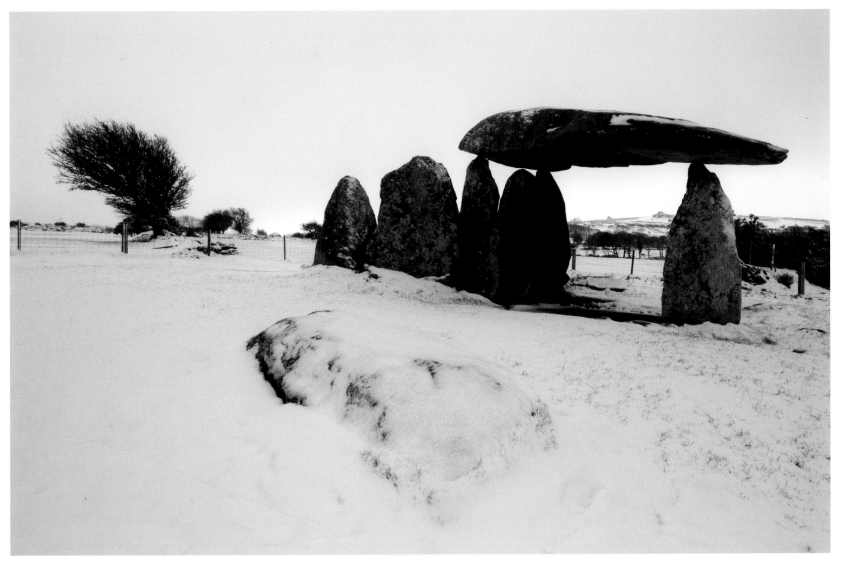

Pentre Ifan, a Neolithic burial chamber dating from approximately 4,500 years ago, seen in the snow. (John Archer-Thomson)

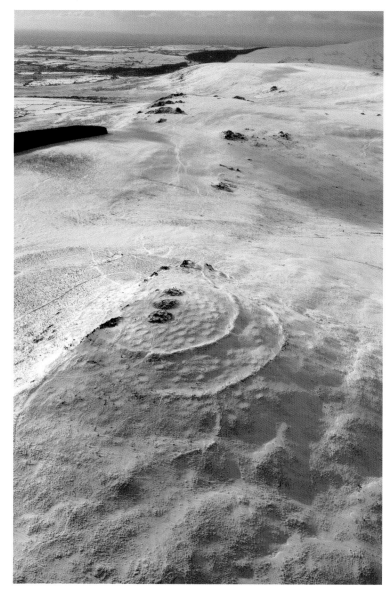

The Iron Age hillfort of Foel Drygarn in the Preseli hills, under snow. The view looks south-west to the distant Carn Meini outcrops, thought to be the site of the prehistoric 'Bluestone' quarries which supplied the smaller stones which stand at Stonehenge, Wiltshire. Foel Drygarn's summit is crowned by three massive stone cairns marking the burial of the dead in the preceding Early Bronze Age. (Toby Driver, Crown Copyright RCAHMW)

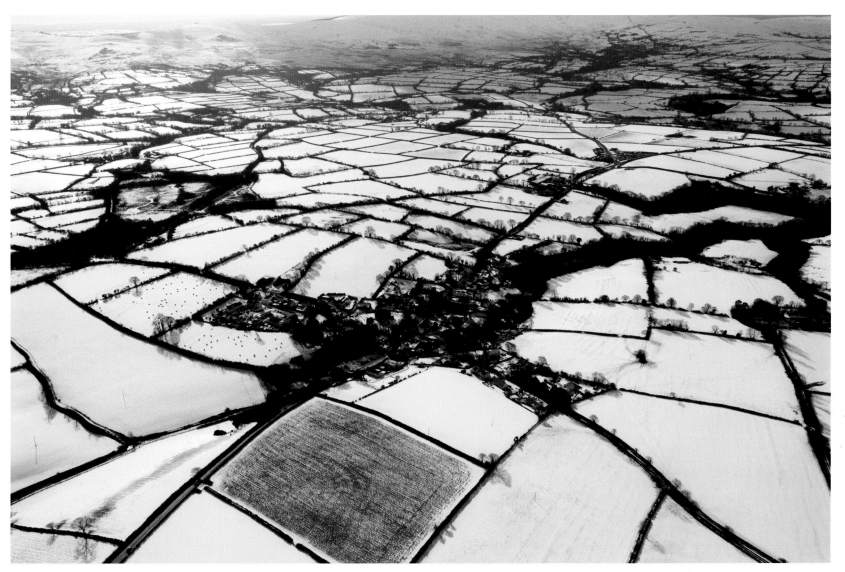

Eglwyswrw in snow. (Toby Driver, Crown Copyright RCAHMW)

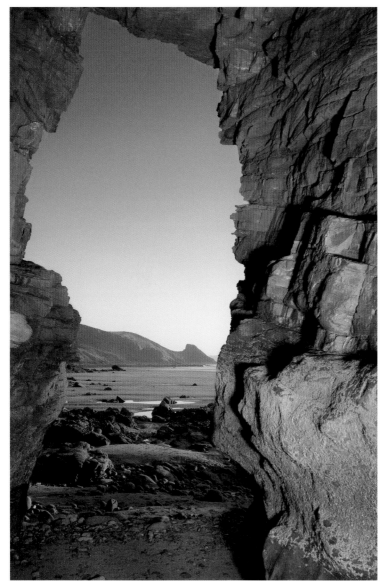

Maidens' Hall is a cave at the south end of Newgale beach where, local tradition has it, in more modest times ladies changed before swimming. In the distance is Ricketts Head. The external view was taken in the late afternoon with an exposure that rendered the cave walls black. After dark the shutter was opened again and the cave walls 'painted' with light from a torch. This is the resulting combination, taken in collaboration with local photographer Gary Roberts. (Richard Hellon)

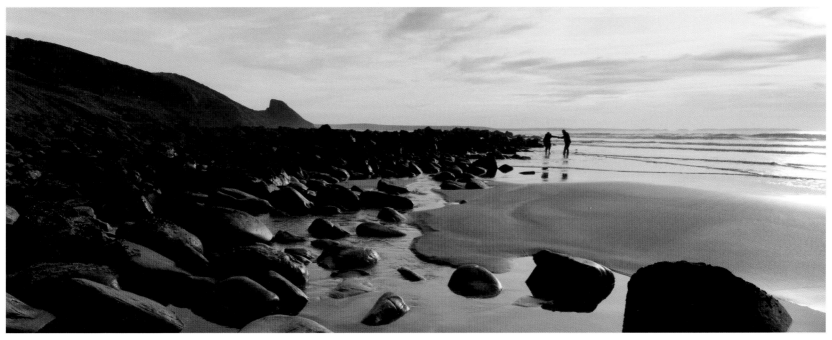

At the southern end of Newgale beach is an area of rounded boulders and pools. Winter sunlight has modelled these to good effect.
(John Archer-Thomson)

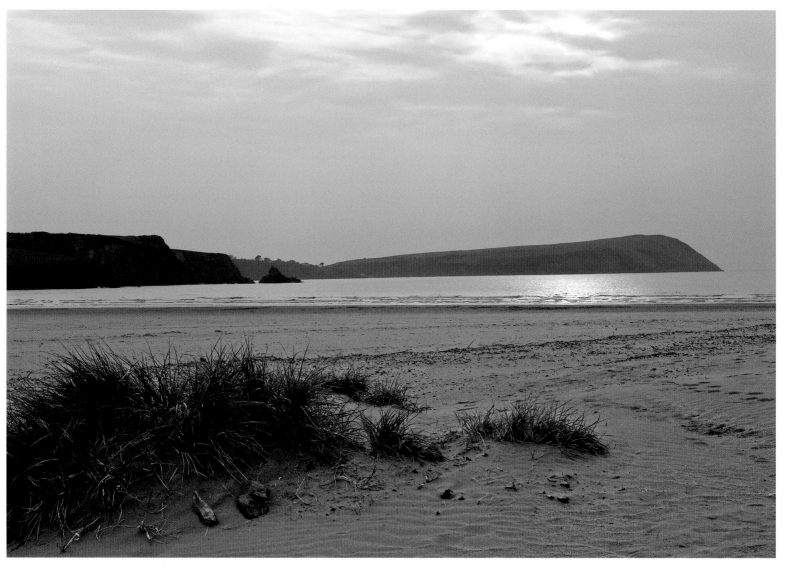

Once an island, Dinas Head is now connected to the mainland by a marshy area which in winter is the haunt of water rails. (Betty Rackham)

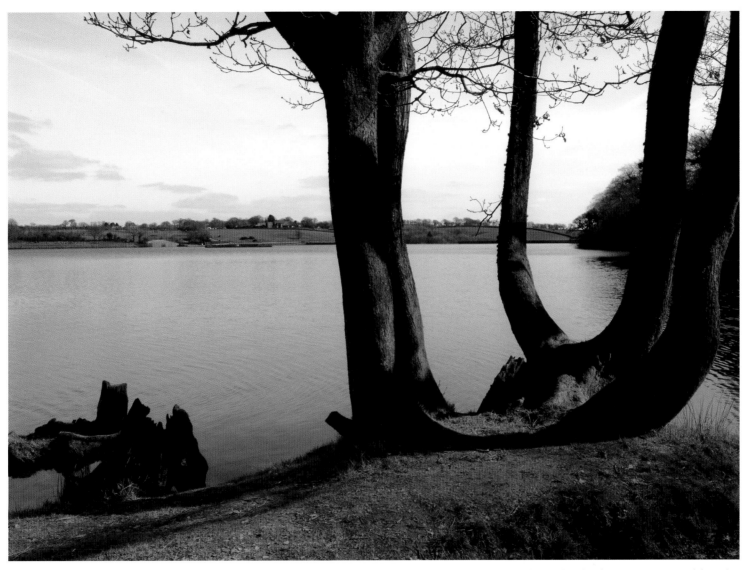

Llys-y-Fran Reservoir is part of Llys-y-Fran country park and supplies water to most of Pembrokeshire. (Tony Rackham)

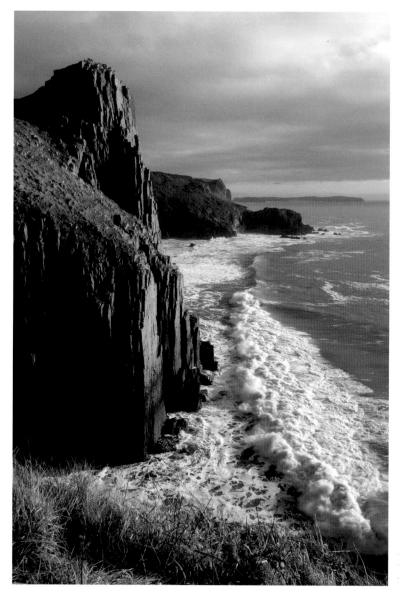

Looking along the coast near Lydstep to Caldey. (John Archer-Thomson)

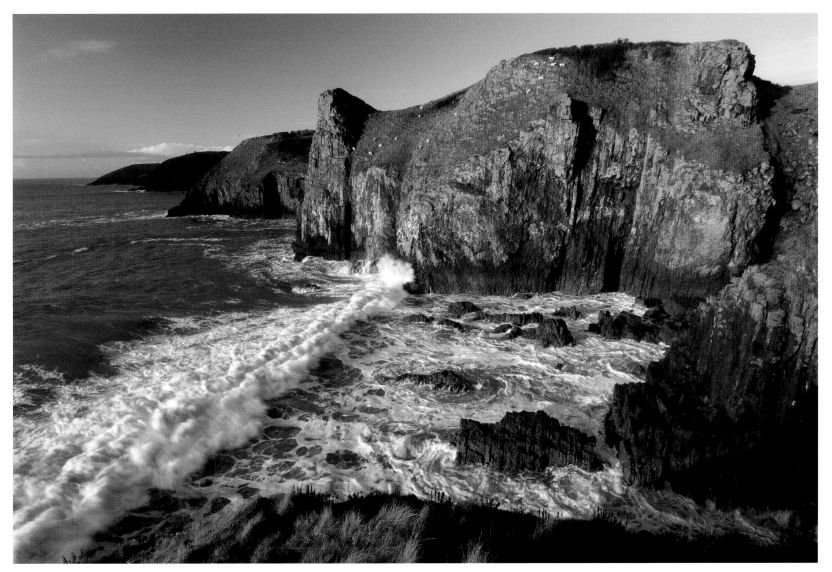

Lydstep to Skrinkle Haven. (John Archer-Thomson)

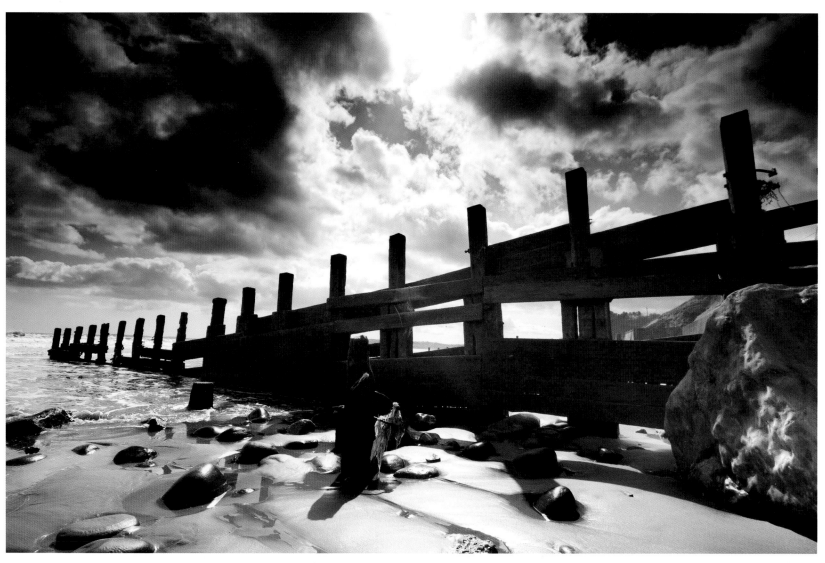

Groynes, seen here at Amroth, are plentiful, but as you head west they disappear, to re-emerge in the harbour of Goodwick. (Adrian Hawke)

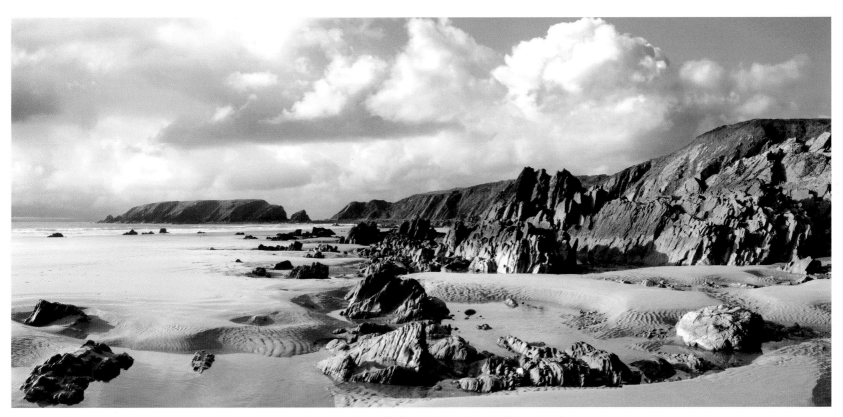

Marloes Sands and Gateholm Island. (Eric Lees)

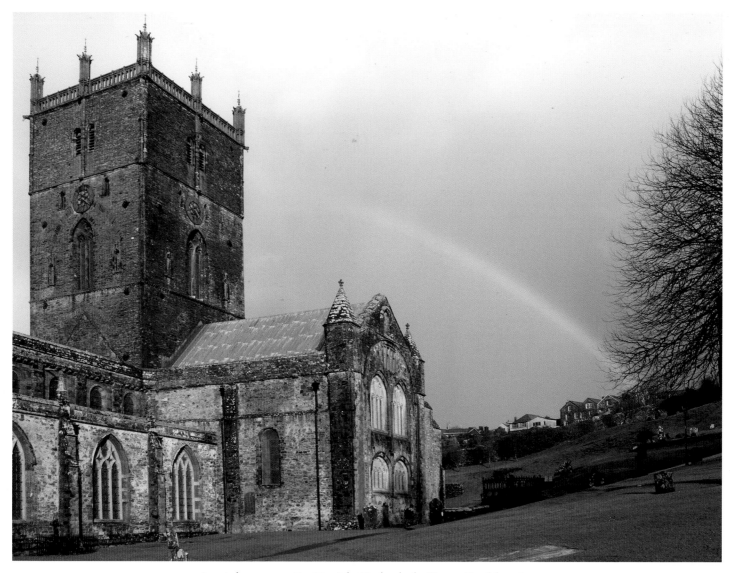

A rainbow over St. Davids Cathedral. (Betty Rackham)

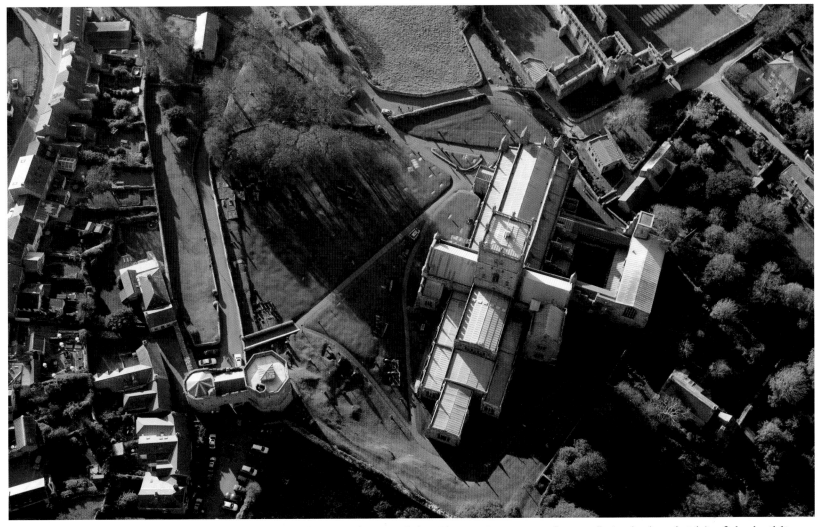

The cathedral and close at St. Davids following the completion of the Cloister Project on the north (right-hand side) of the building. This complex of buildings has remained largely unchanged since medieval times and has long acted as an important centre of pilgrimage. (Toby Driver, Crown Copyright RCAHMW)

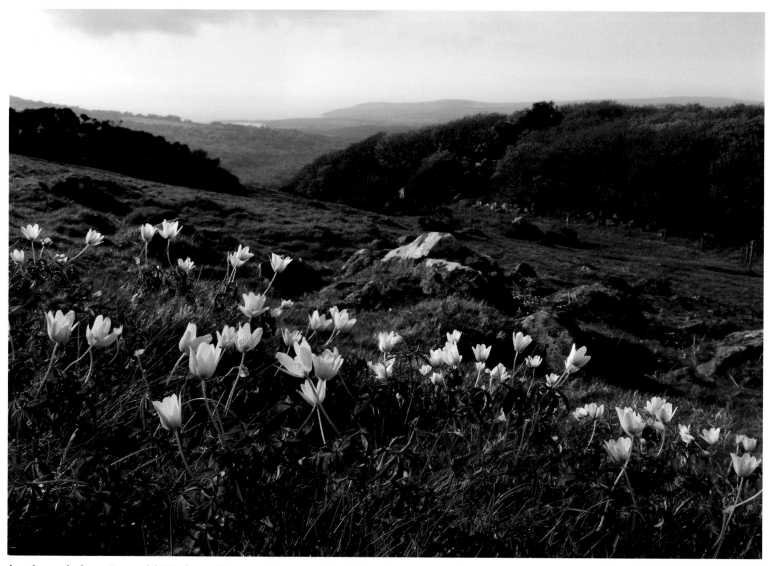

On the slopes below Carnedd Meibion Owen, a large patch of wood anemones looks out towards the Nevern Estuary. (Tony Rackham)

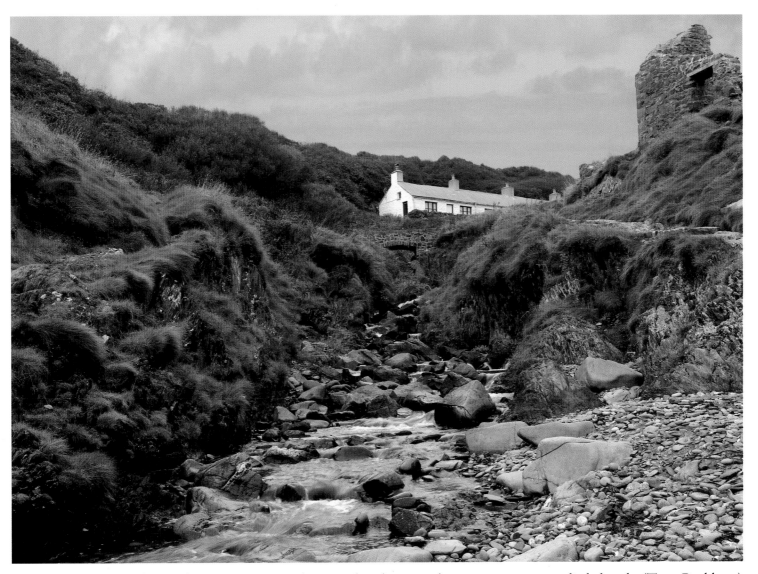

Trefin is a village on the north-east coast. Here the coastal path comes down to a picturesque little beach. (Tony Rackham)

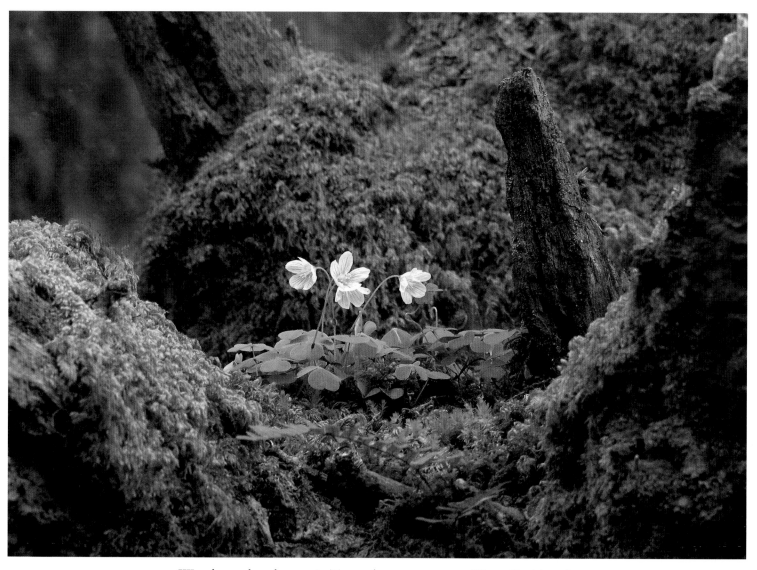

Wood sorrel and moss in Tycanol nature reserve. (Tony Rackham)

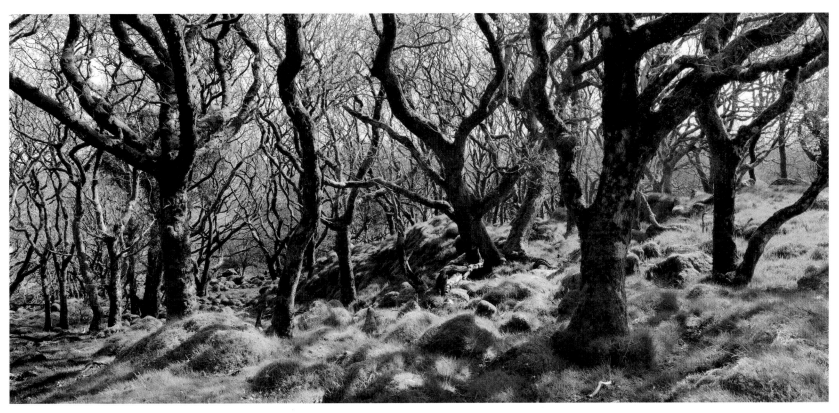

Gnarled oaks over 800 years old and rocky outcrops at Tycanol covered with moss and some 400 species of lichen. (Eric Lees)

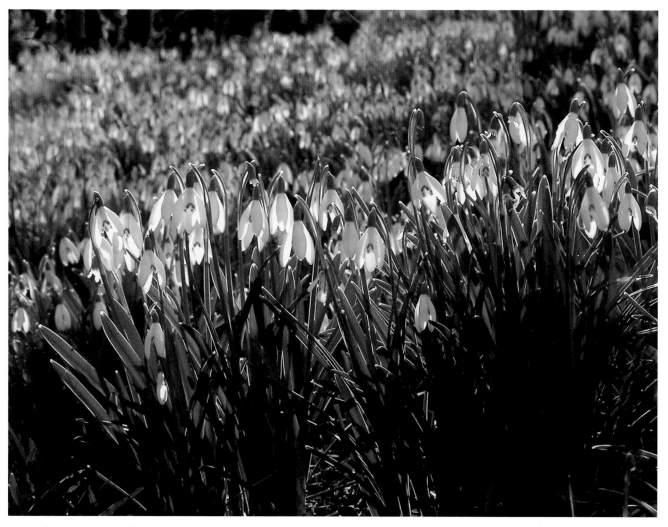

Snowdrops in the Gwaun Valley. In most of Britain snowdrops growing wild are naturalised from garden plants including ones introduced by soldiers returning home from the Crimean War. However in parts of Wales they may well be native — certainly those in Pembrokeshire tend to be later flowering and less open than those found elsewhere. (Tony Rackham)

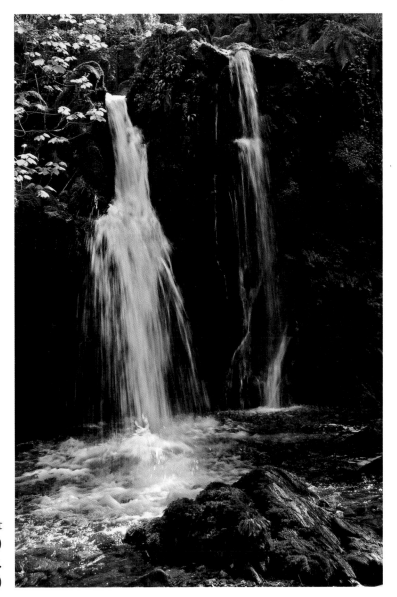

Inland from the beach at Aberfforest
(between Fishguard and Newport)
is a waterfall in a woodland setting.
(Tony Rackham)

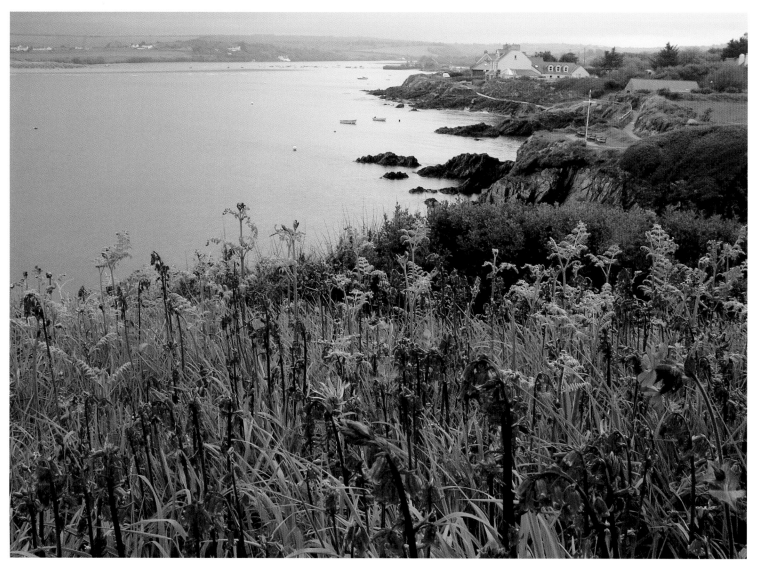

Newport Parrog is a little harbour at the mouth of the Nevern estuary. (Tony Rackham)

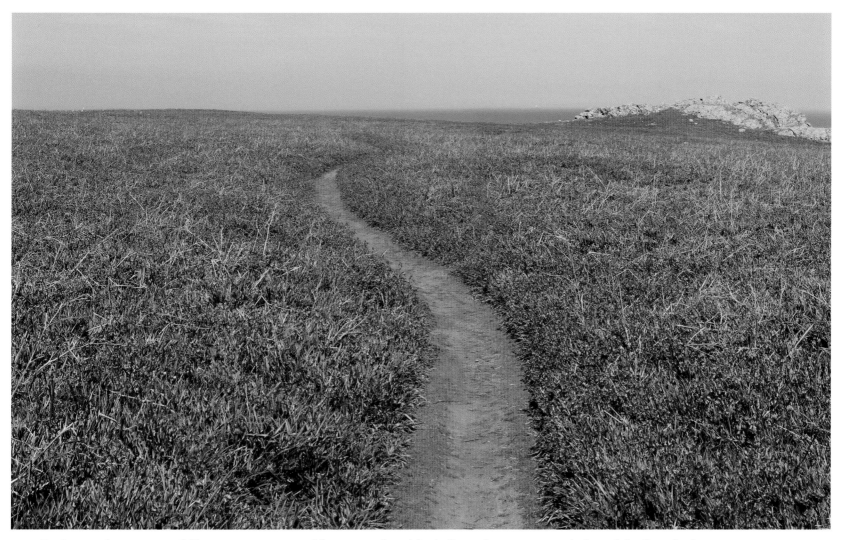

In Spring, large areas of Skomer are a mass of flowers such as bluebells, red campions and also of thrift and white sea campions.
(Tony Rackham)

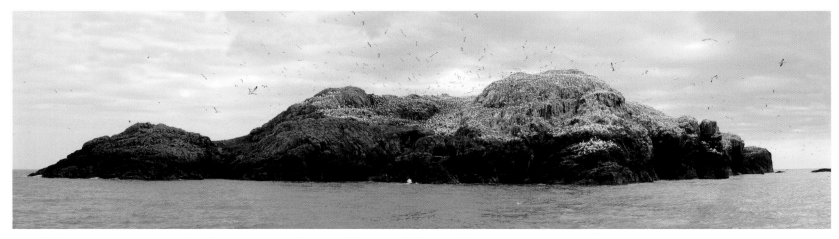

Grassholm. This image was shot from a moving boat to the east of the island and is a composite of nine pictures. (John Archer-Thomson)

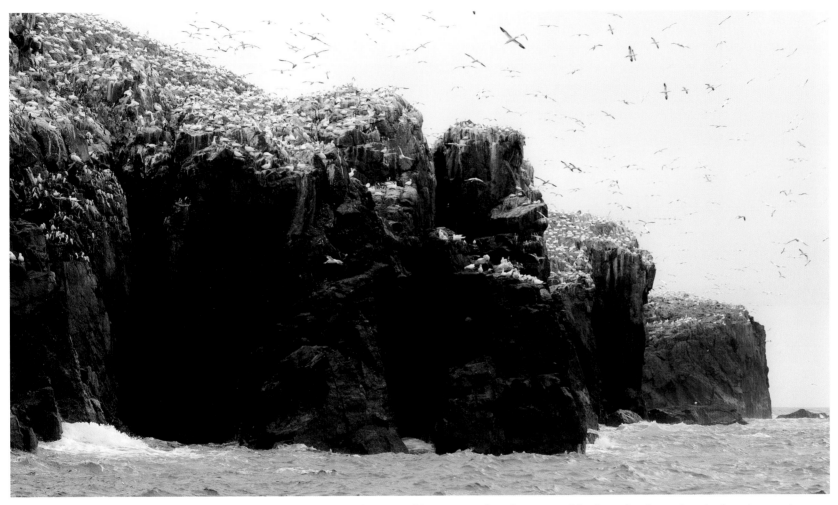

A section of the northern part of Grassholm, giving a flavour of how rugged and inaccessible this island can be. A close inspection of the cliffs on the left will show some guillemots under the gannet colony. (John Archer-Thomson)

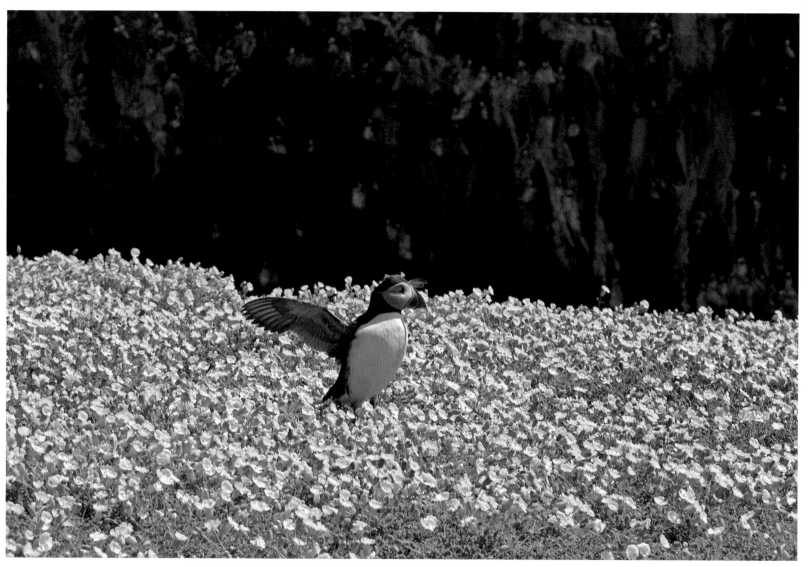

A puffin stretches its wings among the sea campions on Skomer. They nest in burrows made either by rabbits or themselves. (Betty Rackham)

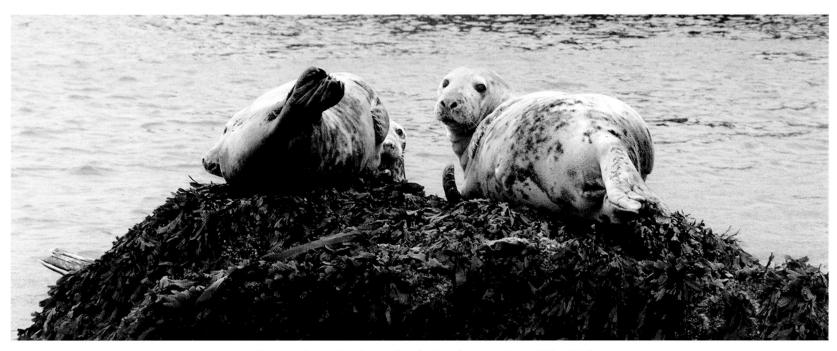

Grey seals on Stack Rocks, St. Brides Bay. (Lisa Whitfeld)

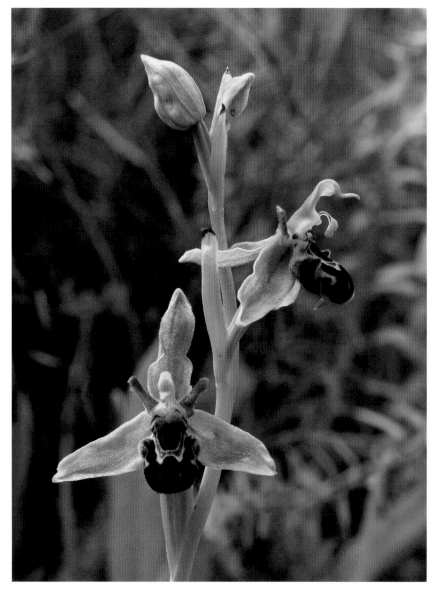

Bee orchid on Newport Dunes.
(Tony Rackham)

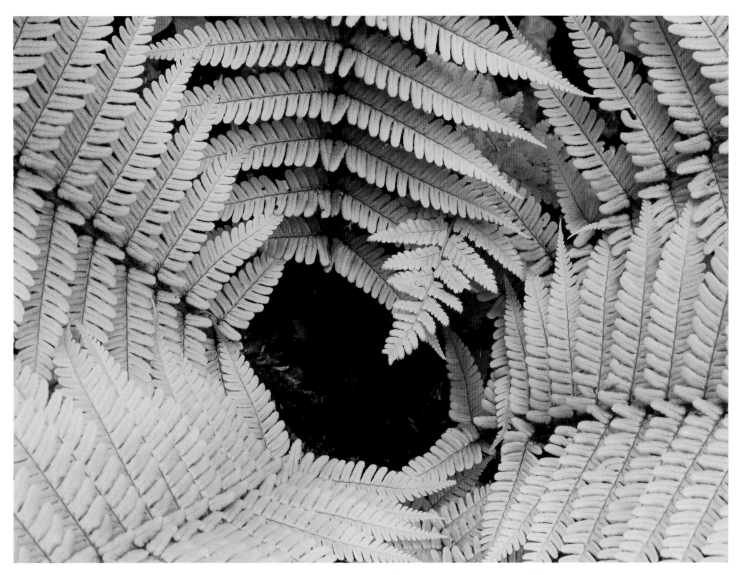

The heart of a scaly male fern in Pengelli Wood. (Betty Rackham)

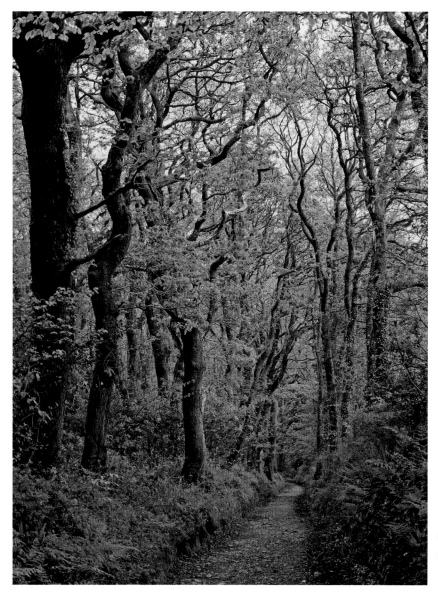

Sessile oaks form a cathedral-like nave
at the entrance to Pengelli Wood.
(Betty Rackham)

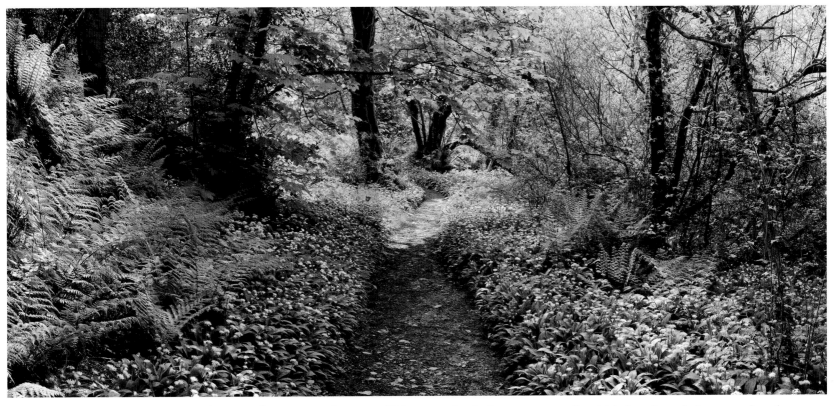

The small wooded valley of Cwm Rhigian, a mile west of Newport, leads down to a small pebble beach and the coastal path. In May this meandering path is lined with ransoms and bluebells. (Eric Lees)

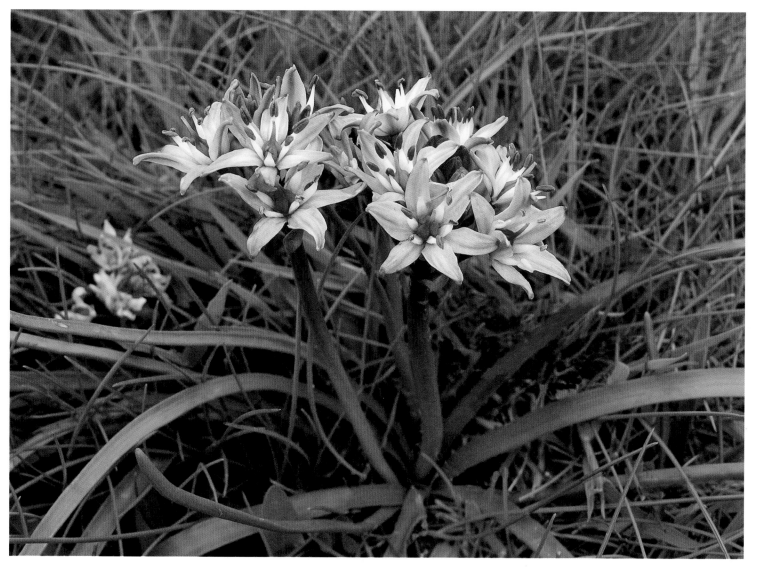

Spring squill growing on the cliffs near Newport. (Betty Rackham)

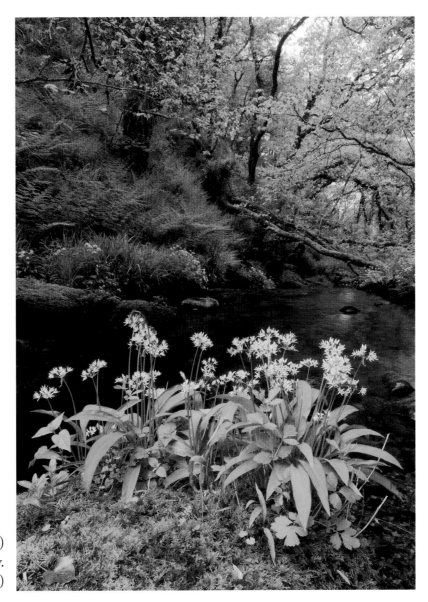

Wild garlic (*Allium ursinum*)
in the Gwaun Valley.
(John Archer-Thomson)

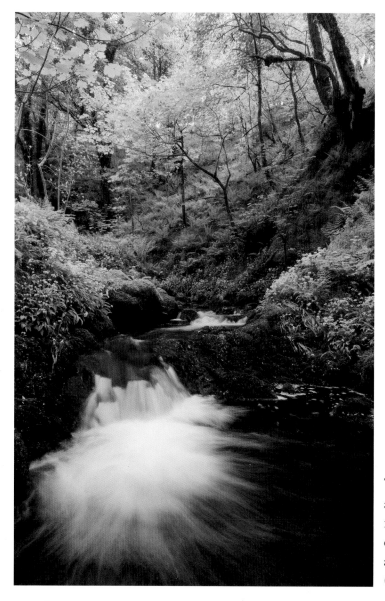

The Gwaun Valley. The use of a slow shutter speed blurs the flowing stream water to good effect on both this photograph and that opposite. (John Archer-Thomson)

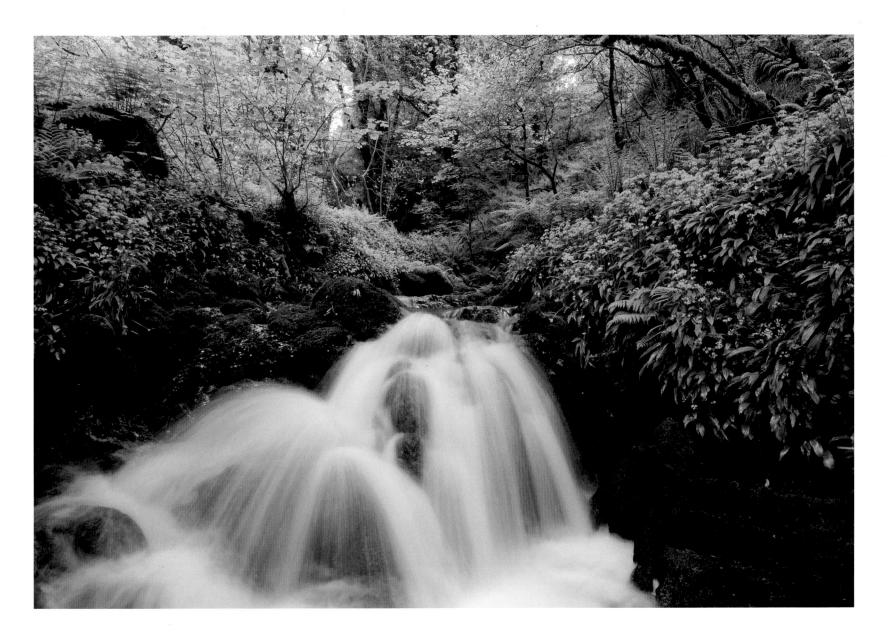

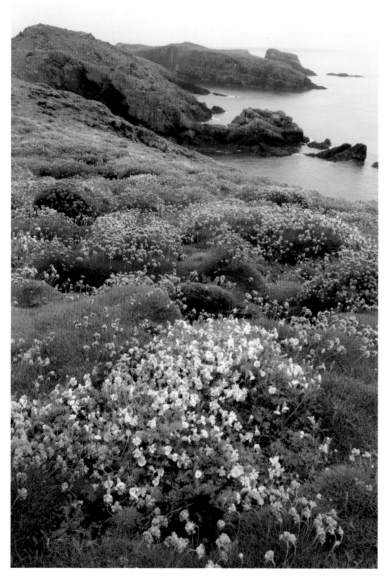

Even though the cliffs here at Skomer Head are 60m high the (white) sea campion and (pink) thrift flowers are regularly subjected to salt spray from the Atlantic Ocean below. The view looks towards the south and shows Tom's House (the jumble of rocks in the middle distance), the Wick (the far inlet, one of the biggest breeding seabird colonies in southern Britain) and St. Ann's Head (the part of the mainland visible on the horizon). (John Archer-Thomson)

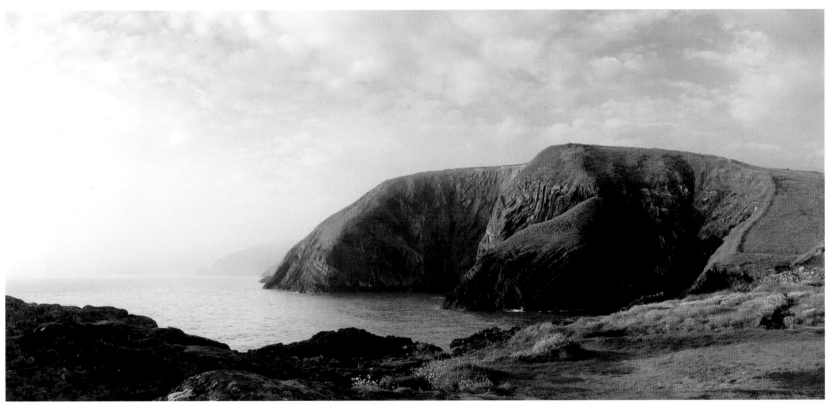

The cove at Ceibwr is the only break in the forbidding stretch of cliffs from Camaes Head to the north and Newport in the south. This lonely part of the coast is excellent for wildlife watching. Seabirds include gulls, fulmars, shags, cormorants and choughs. (Eric Lees)

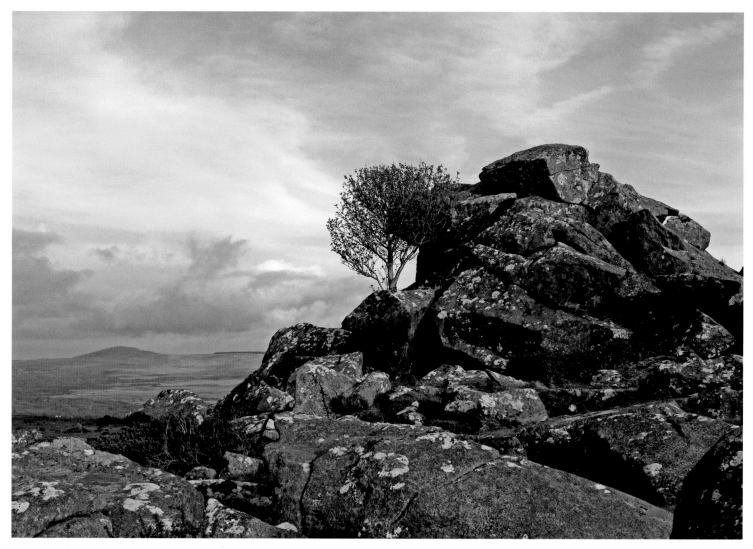

A glimpse of Frenni Fawr from Carnedd Meibion Owen. Characterised by a line of cairns, this mountain lies to the north of the main Preseli range. Below the mountain to the north lies Tycanol Wood and on the other side, Brynberian Bog. (Betty Rackham)

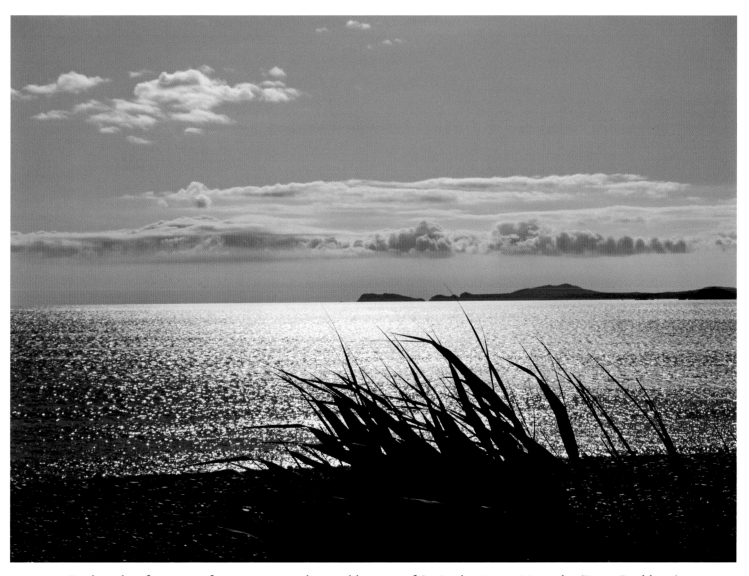

Dark rushes form a perfect contrast to the sparkling sea of St. Brides Bay at Newgale. (Betty Rackham)

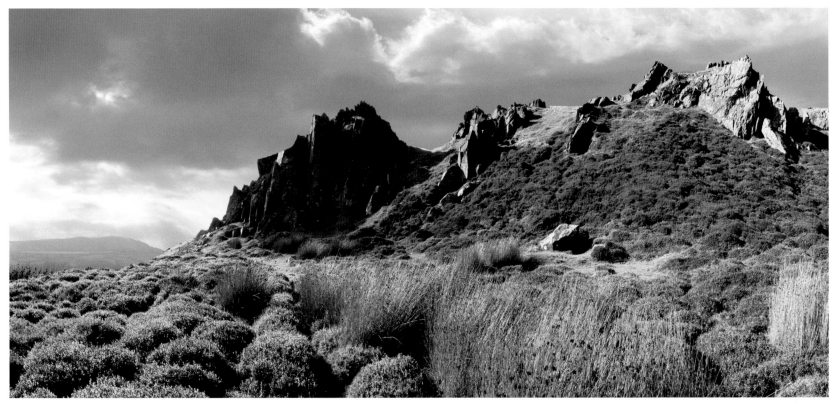

A site of Bronze and Iron Age earthworks, the craggy slopes of Foel Drygarn in the Preseli hills overlooks the central plain of wild heatherclad moorlands where birds of prey can often be seen hovering over the heights and wild ponies and sheep graze freely. (Eric Lees)

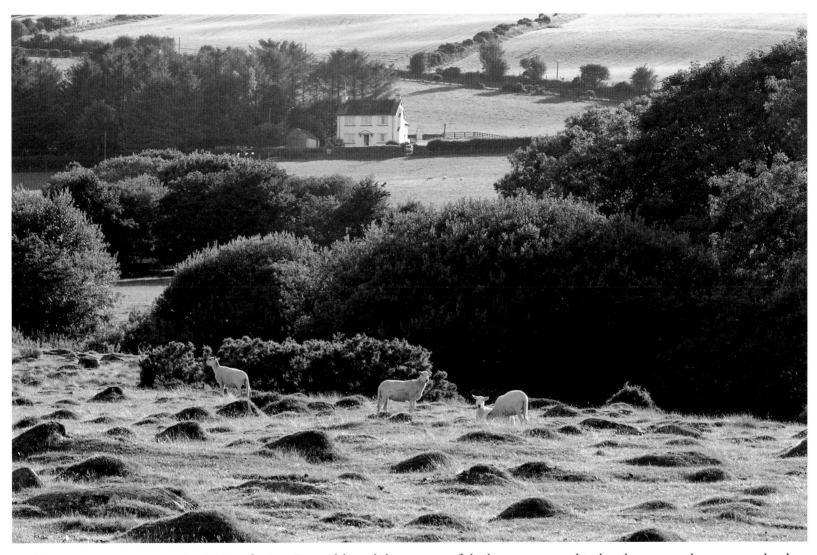

Sheep on a summer evening in Brynberian Bog. Although large areas of the bog are covered in bracken, enough open grassland remains for grazing. The ancient turf is dotted with rocks and old ant hills. (Betty Rackham)

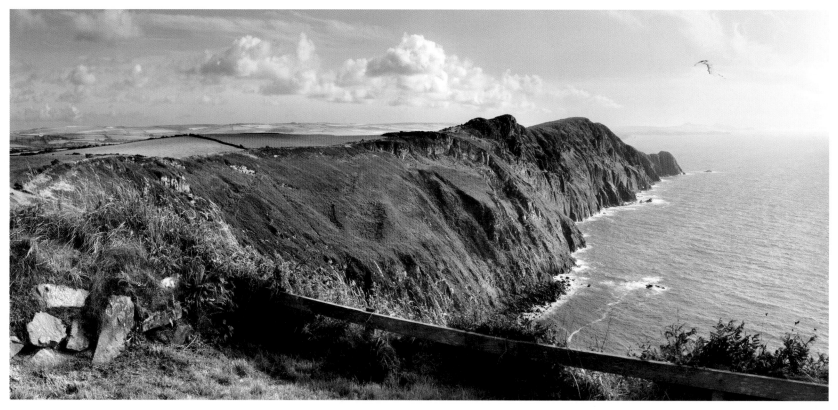

Positioned in north Pembrokeshire below Strumble Head on the coastal path, the dramatic headland at Pwll Deri consists of high wild precipitous cliffs with extensive views and an abundance of wildlife. (Eric Lees)

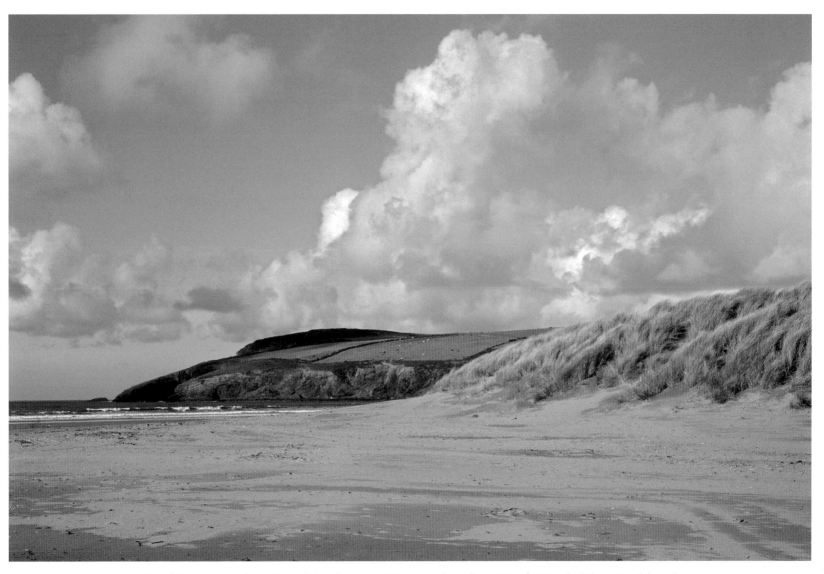

Looking across the edge of the dunes at Newport beach to Morfa Head. (Tony Rackham)

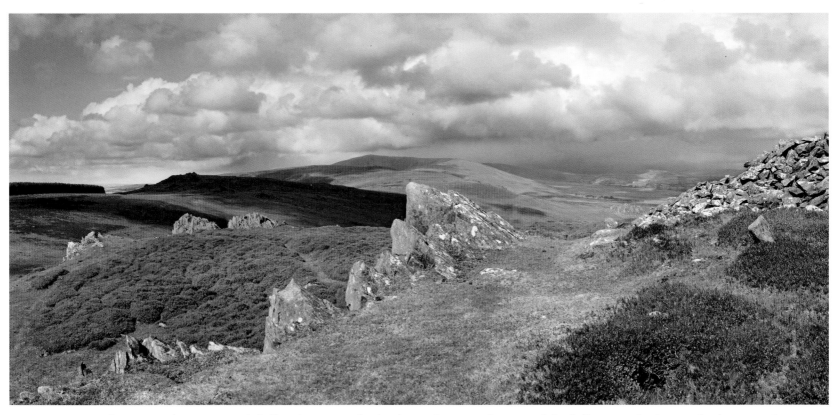

Approaching rain shower, Preseli hills. This image looks down the central spine of the hills towards Carningli. (Eric Lees)

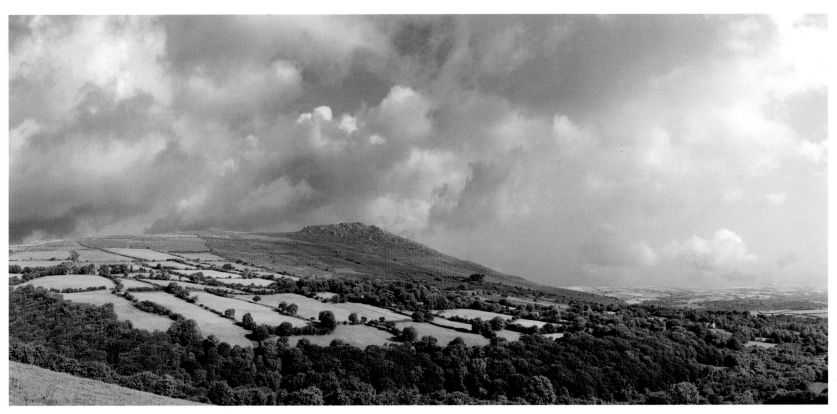

Carningli at 347m, with its rocky outcrop and prehistoric hillfort, gives wide views of moorland and the northern coastline. (Eric Lees)

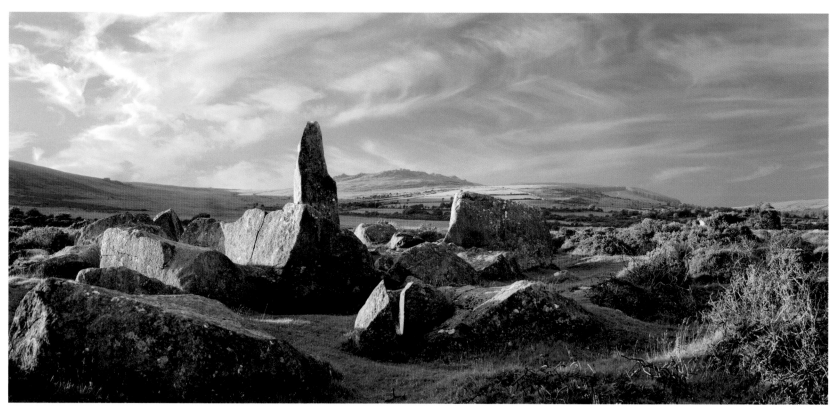

Evening on the Preseli hills near scattered remains of stone circles, burial chambers and standing stones. (Eric Lees)

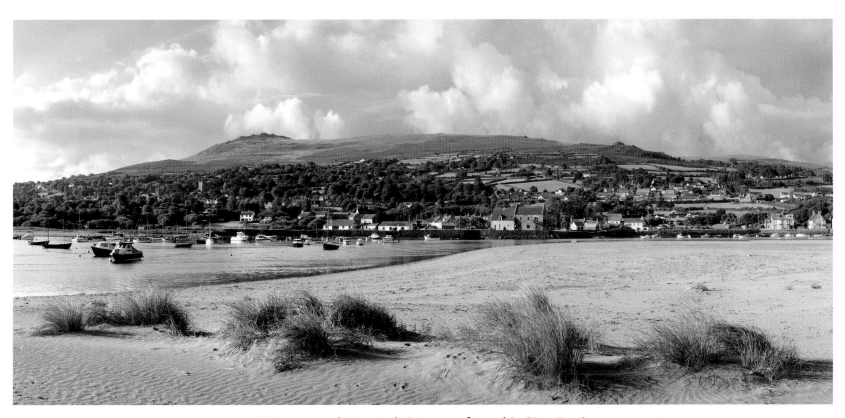

Newport and Carningli (Mount of Angels). (Eric Lees)

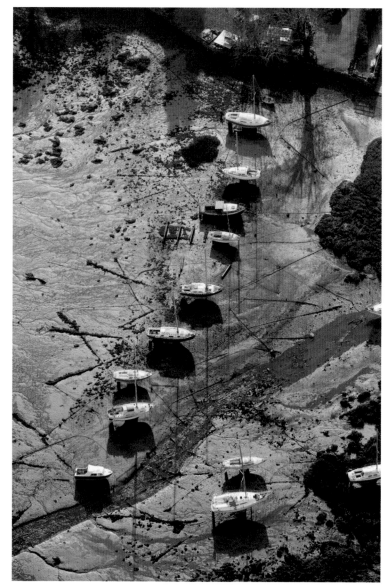

Boats at Angle standing proud at low tide. Situated on the southern shores of the Milford Haven waterway, Angle was a thriving medieval settlement and harbour with a strong maritime tradition which continues into the present day. To an aerial archaeologist, expanses of intertidal mud close to historic harbours and ports are a constant source of fascination for their hidden potential; storm scours and shifts in the mud can reveal previously hidden historic structures such as old wharves and jetties, fish traps, or even wrecks and hulks. (Toby Driver, Crown Copyright RCAHMW)

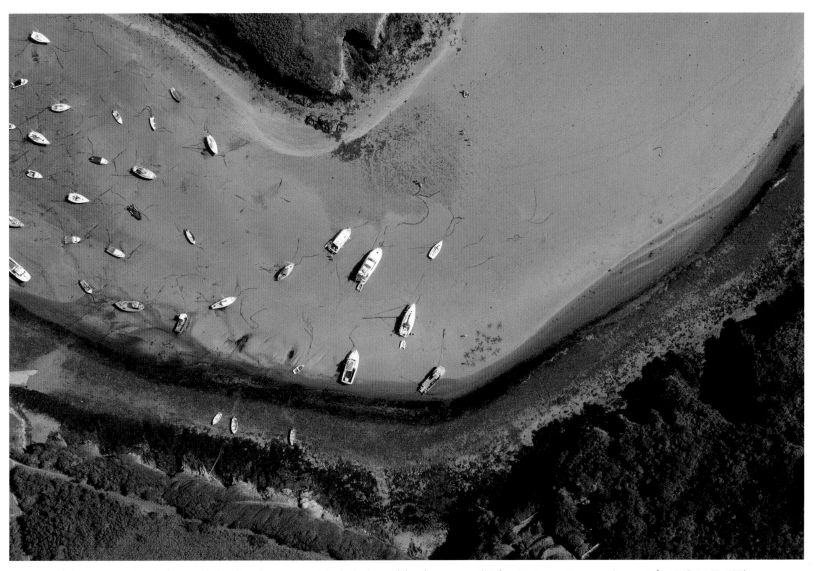

The narrowing inlet at Solva has long provided sheltered harbourage. (Toby Driver, Crown Copyright RCAHMW)

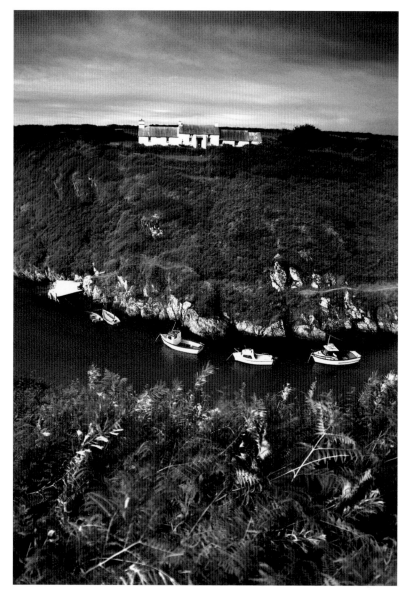

Porthclais Harbour. A classic Pembrokeshire scene. The tide has filled the harbour and the boats wait patiently to set off, overlooked by a quintessential Pembrokeshire cottage, typical of the area. Owned by the National Trust and managed by the harbour authority and the PCNPA, the harbour is part of an SSSI located on St. Davids' peninsula. (Adrian Hawke)

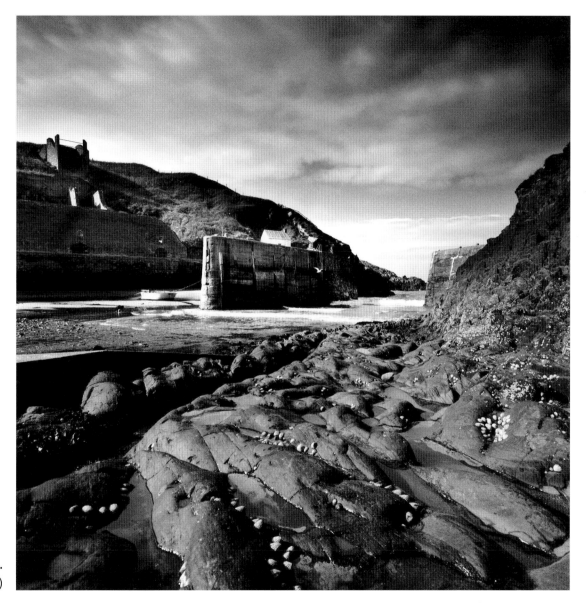

Low tide at Porthgain.
(Adrian Hawke)

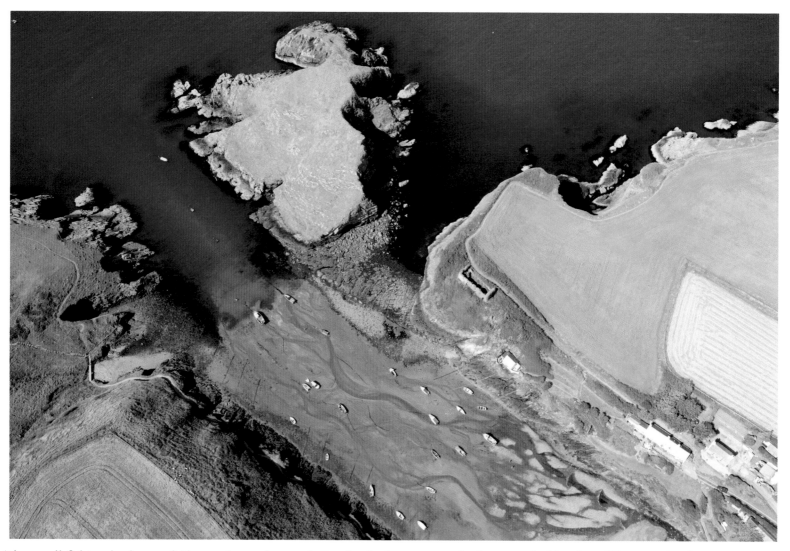

The small fishing harbour of Abercastle on the north Pembrokeshire coast, which is guarded by the offshore rock of Ynys y Castell, the site of an Iron Age coastal fort. (Toby Driver, Crown Copyright RCAHMW)

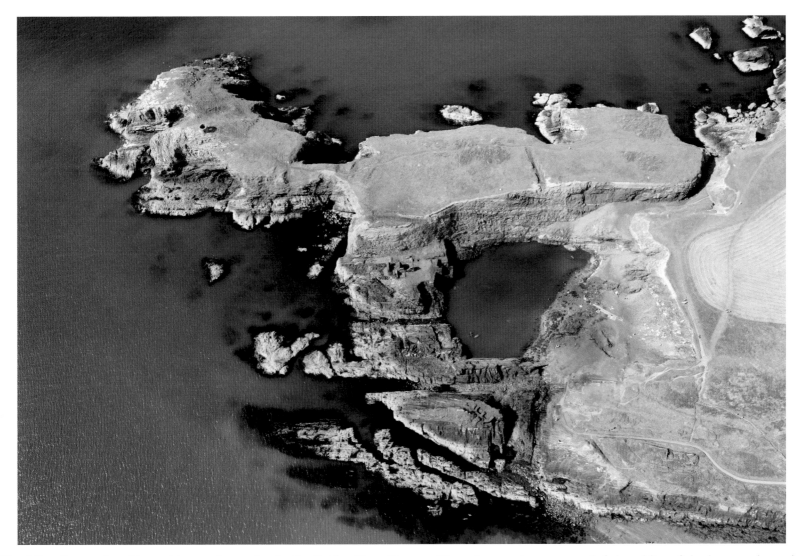

The 'Blue Lagoon' at Abereiddi was formerly the St. Brides Slate Quarry. The ruins on the western, left-hand lip of the lagoon show the former site of the engine house and other buildings associated with the quarry operations. (Toby Driver, Crown Copyright RCAHMW)

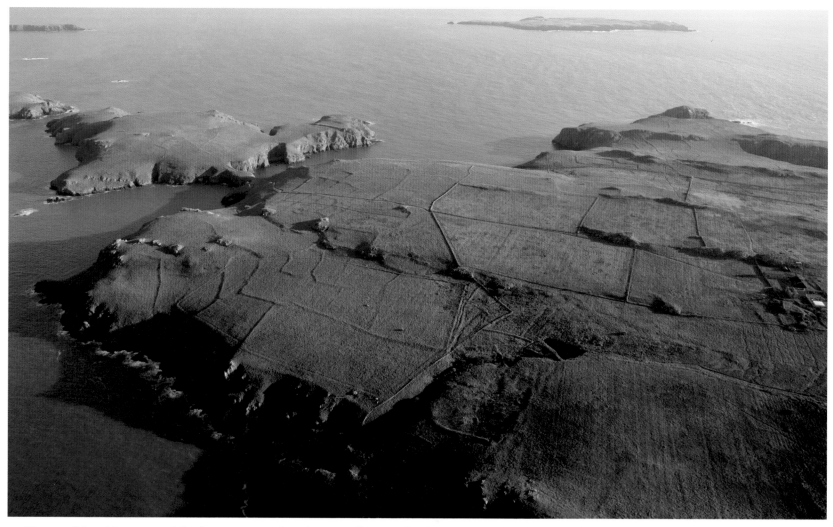

Skomer Island has one of the best preserved prehistoric farming landscapes in Britain, with a legacy of field terraces, stone field walls and the footings of roundhouses. Substantial field terraces, or 'lynchets', like those on Skomer only accumulate where decades or centuries of ploughing have moved topsoil downslope. (Toby Driver, Crown Copyright RCAHMW)

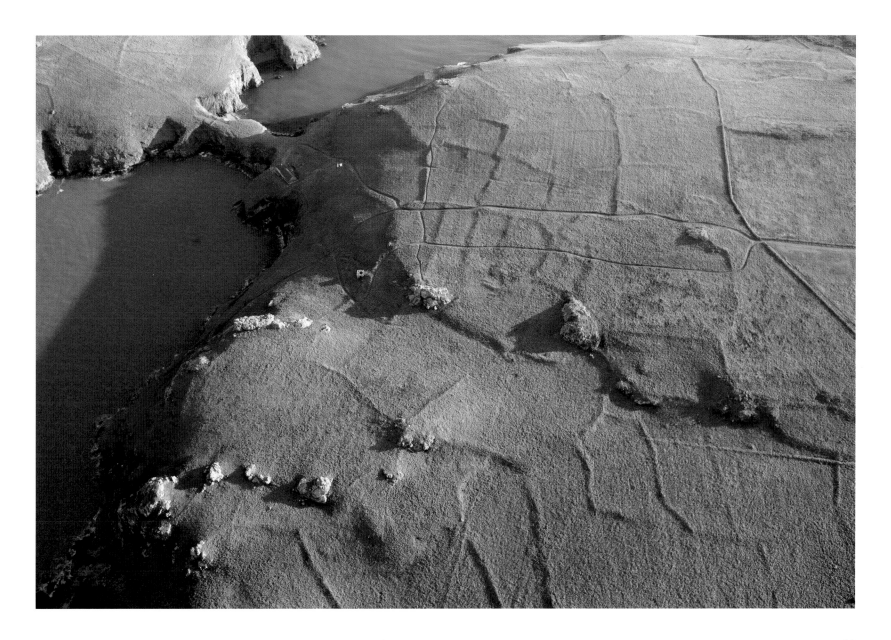

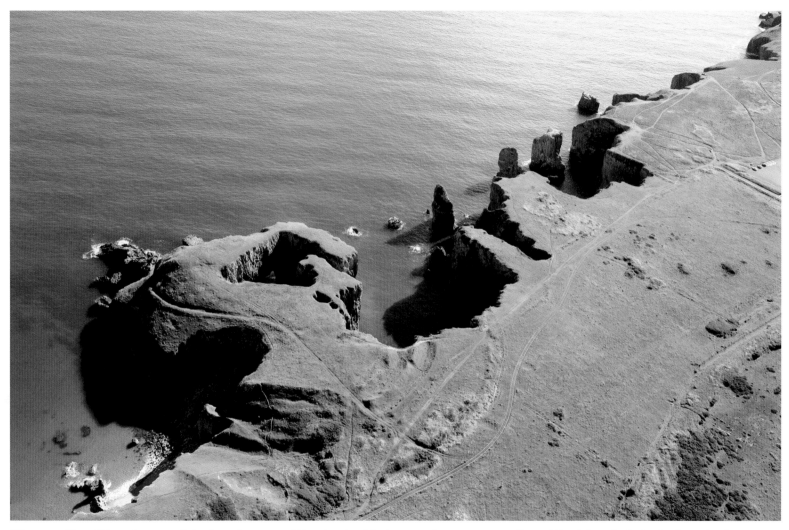

Flimston Bay Camp is one of the best known of Pembrokeshire's coastal promontory forts. The blow-hole in its interior known as 'the cauldron' probably formed a prominent feature even in prehistory. Looking west along the coast, one sees first the nearby Elegug Stacks (upper right) and the arch of the Green Bridge of Wales (partly hidden in this view). (Toby Driver, Crown Copyright RCAHMW)

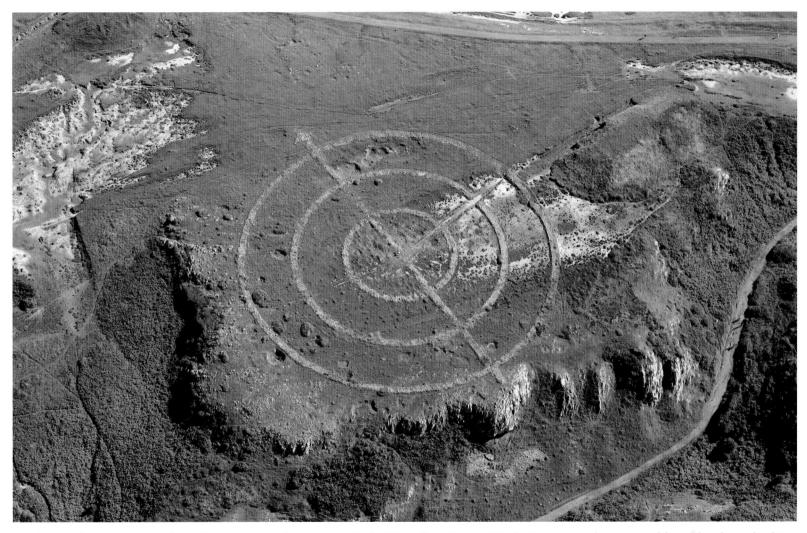

On the south-eastern tip of the Castlemartin firing range is the Trevallen Downs Tank Range, sited on coastal heathland overlooking St. Govans Head. Among blockhouses, bunkers and disused tramways for mobile targets is this aerial bombing target, constructed of local limestone, measuring almost 100m in diameter. (Toby Driver, Crown Copyright RCAHMW)

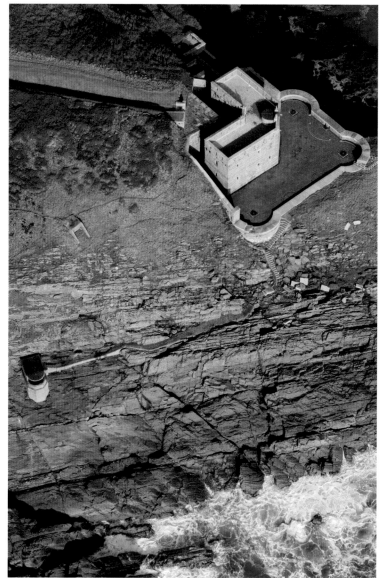

Sited on the wave-washed tip of the western headland flanking the entrance to the Milford Haven waterway, the 19th-century West Blockhouse Fort was originally built to defend against the threat of a French invasion. In the Second World War, modern concrete structures of the West Blockhouse Battery were constructed on the headland above, and included concrete Coastal Artillery Searchlight Batteries perilously sited on the sea-cliffs (at lower left), and on the forward angles of the lower fort walls (since removed). (Toby Driver, Crown Copyright RCAHMW)

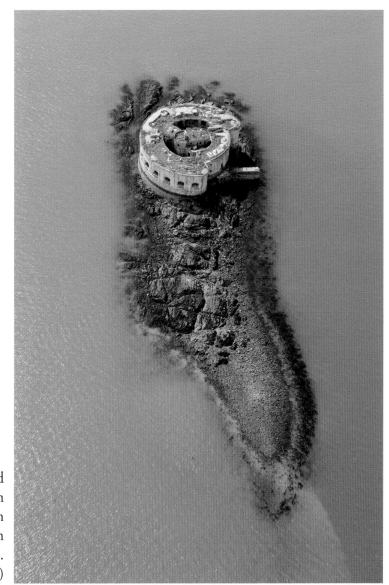

Stack Rock fort at low tide. Occupying an isolated rock at the western end of the Milford Haven waterway, this island fort was erected in 1852 in response to the perceived threat of a French invasion in the decades following the Battle of Waterloo. (Toby Driver, Crown Copyright RCAHMW)

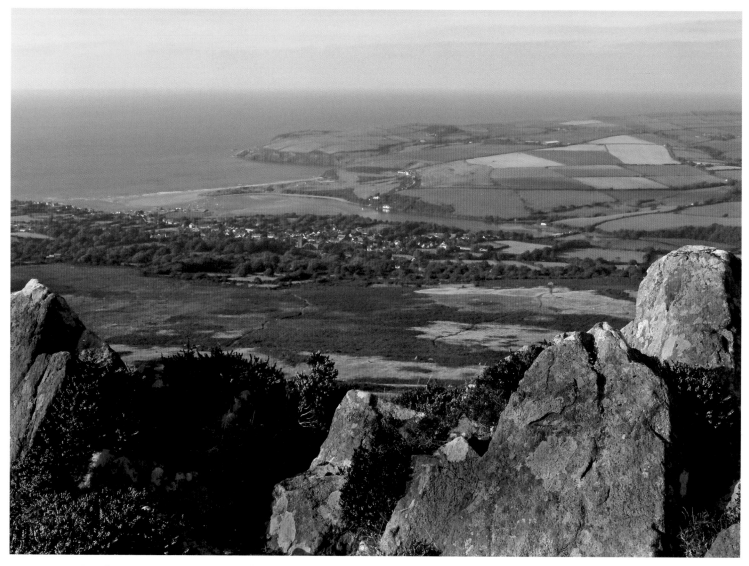

Looking across Newport and the Nevern estuary to Morfa Head from Carningli. (Tony Rackham)

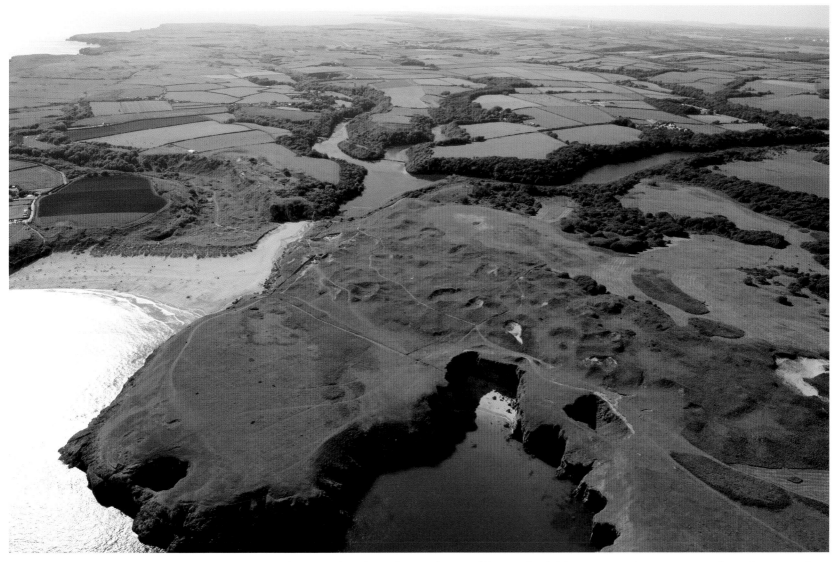

Stackpole Warren, looking west across Broad Haven beach to the Bosherton lily ponds. (Toby Driver, Crown Copyright RCAHMW)

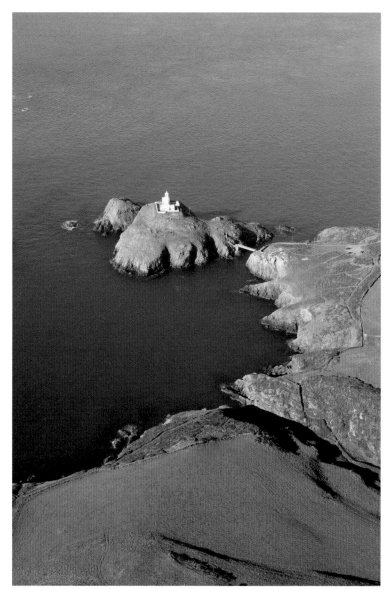

Sited on Ynys Meicel rock at the north-west tip of Pen Caer/Strumble Head, Strumble Head lighthouse was built in 1908-9 to enable ships to navigate safely into Fishguard Harbour. (Toby Driver, Crown Copyright RCAHMW)

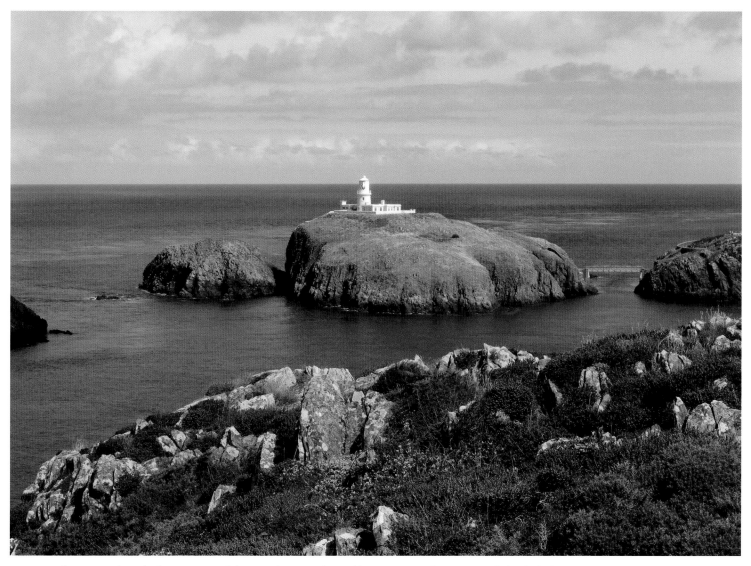

The coastal path from Strumble Head towards Pwll Deri provides views of the lighthouse. (Tony Rackham)

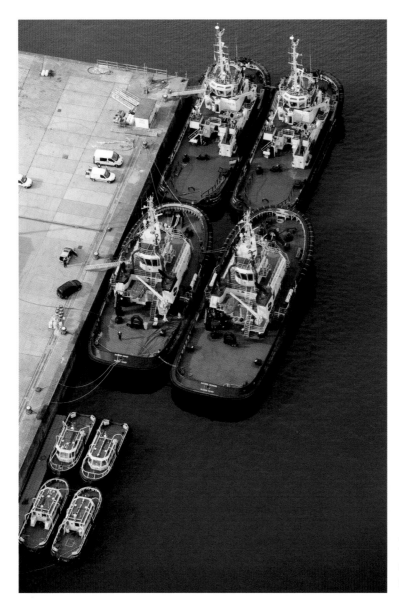

Four Port Authority tugs tied up at Pembroke Dock. (Toby Driver, Crown Copyright RCAHMW)

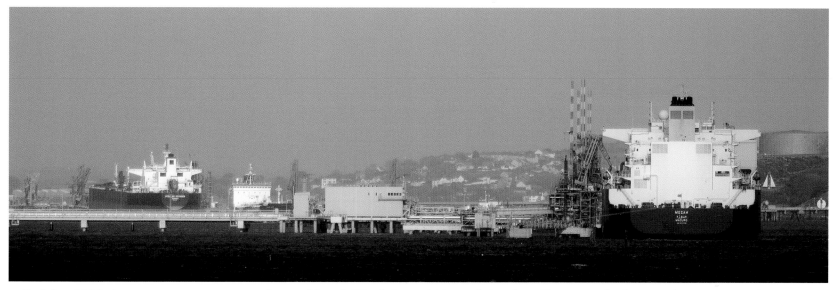

In May 2009 the massive construction phase of South Hook Liquid Natural Gas (LNG) storage facility, at what was once the ESSO refinery at the entrance to Milford Haven waterway, was completed. Gas is transported from Qatar, in the Arabian Gulf, as a liquid at -160°C and as such only occupies 1/600th of the volume it would occupy as a gas. The liquid is converted to gas for domestic supply. This facility is the largest of its kind in Europe and is one of two in the Milford Haven waterway. The tanker on the right is a new LNG carrier; the tanker in the background, to the left, is a crude oil transporter. (John Archer-Thomson)

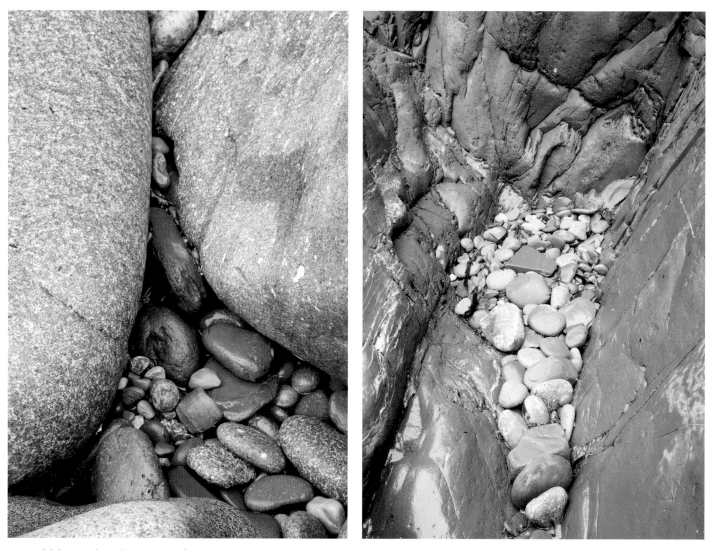

Pebbles and rocks at Caerfai Bay, St. Davids, showing the wide variety of rock types which can be found here. The purple stone is also found at Caerbwdi Quarry and was used to build the cathedral. (Richard Hellon)

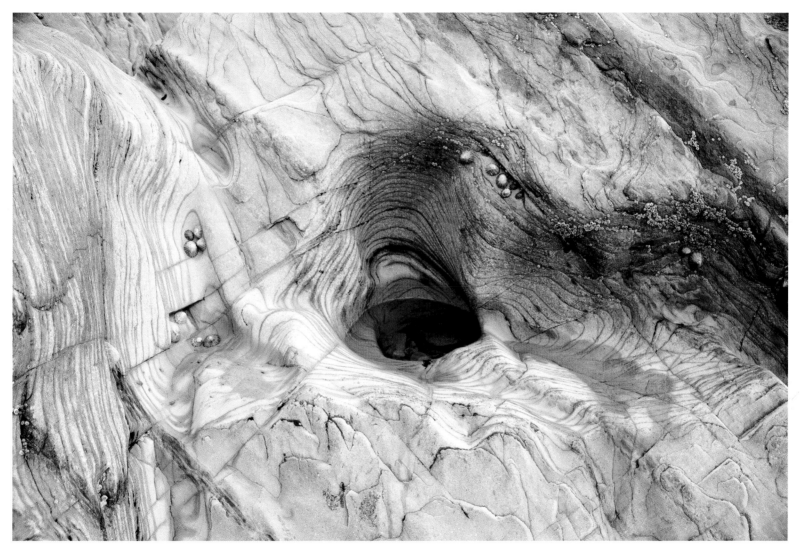

Wave erosion and the scouring action of pebbles have shaped the bedrock at Whitesands Bay so that it resembles a piscina in the chancel of a church. The exposed strata seem to look like the contour lines on a map. (Richard Hellon)

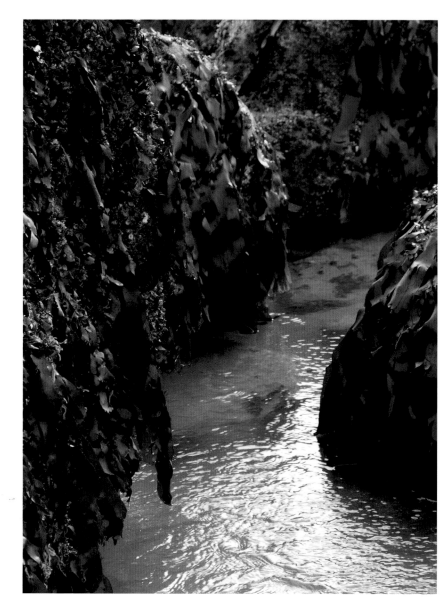

Red dulse seaweed on rocks at Newgale. Lava bread also grows on the rocks but can only be collected by licence. (Betty Rackham)

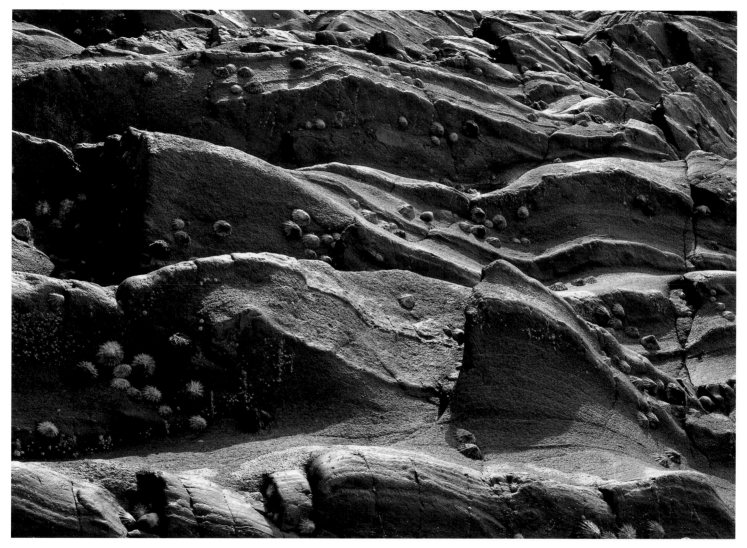

Limpets form patterns with the rock strata at Aberbach, near Dinas. These molluscs are very territorial and although they wander around to browse on algae when covered by the sea, will always return to the same place. (Betty Rackham)

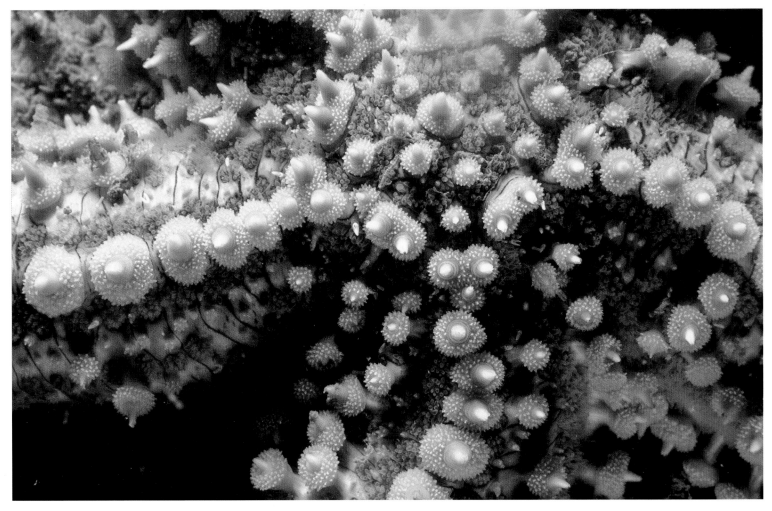

A close-up of a spiny starfish (*Marthasterias glacialis*). Measuring some 30cm across, it is a useful species in a number of ways. Being at the northern end of its distributional range, it is sensitive to changes in seawater temperature and so can be used to help monitor global temperature changes. Secondly, like starfish in general, it can regenerate lost limbs if the occasion arises, but this species so excels at regeneration that an artificial version of its 'growth-regulating' chemicals is being used in the fight against cancer. (John Archer-Thomson)

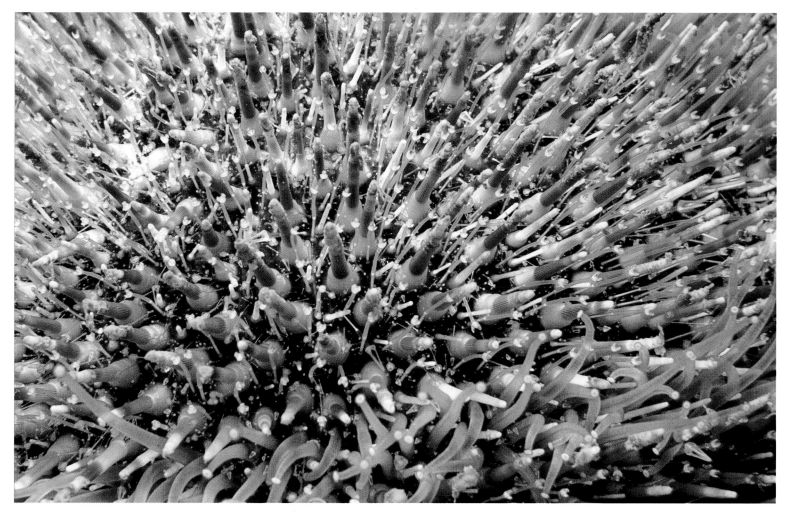

A close up of the body surface of the sea urchin (*Echinus esculentus*), which is a common underwater species in the Marine Nature Reserve, present in many different colours. The purple spines are for protection, whilst the tiny projections in between the spines are manipulated to clean its body surface. The soft, longer projections in a band at the bottom of the image, are called 'tube feet' and are the equivalent of our locomotive system. (John Archer-Thomson)

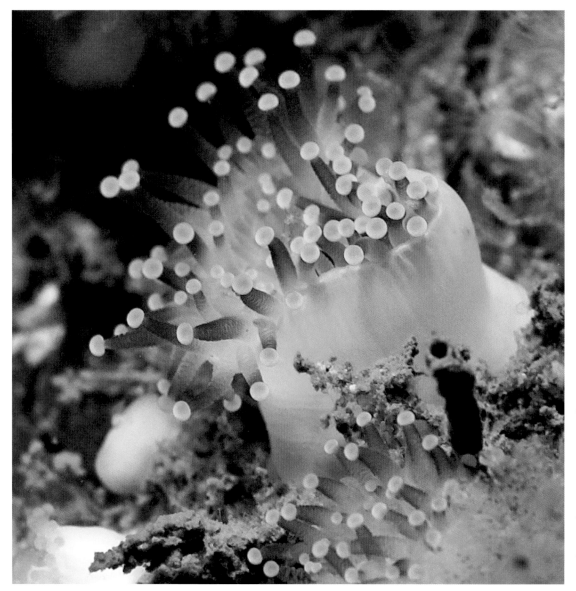

Jewel Anemone (*Corynactis viridis*). Although this is a single animal, groups can collectively completely cover rock faces providing a spectacular display in a variety of colours: pinks, purples, reads, oranges, yellows, greens, browns and more. (Lisa Whitfeld)

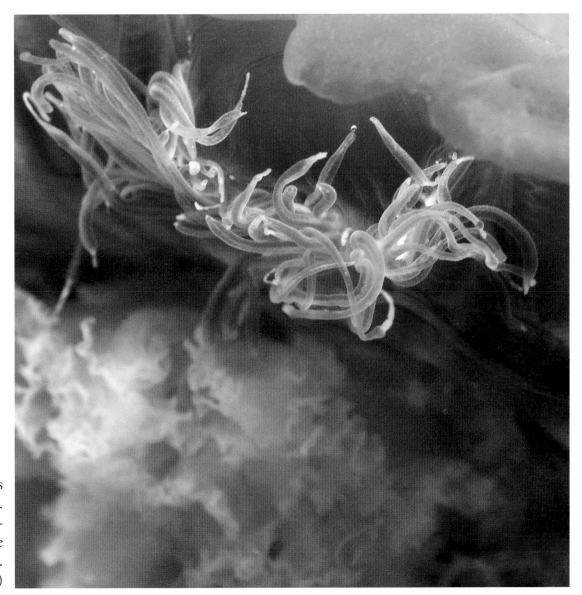

Cyanea-lamarckii, sometimes known as the Blue Jellyfish. This individual was swimming near the surface of the sea in St. Martin's Haven. (Lisa Whitfeld)

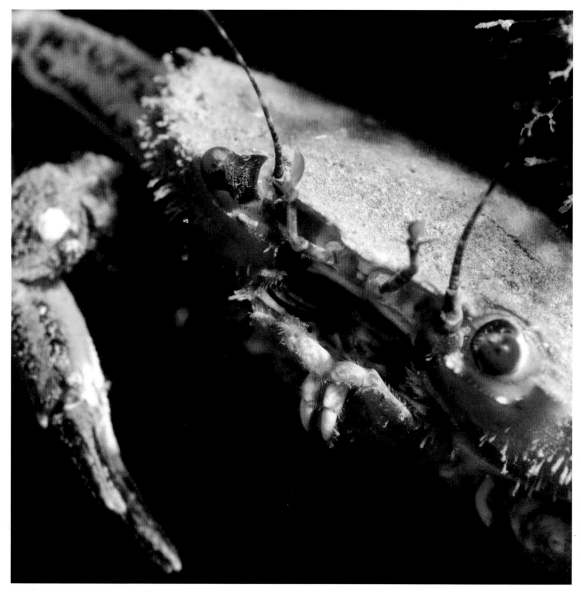

Velvet Swimming Crab (*Necora puber*). This is an audacious fiery-eyed crab, ready to challenge a diver with spread claws rather than running away! (Lisa Whitfeld)

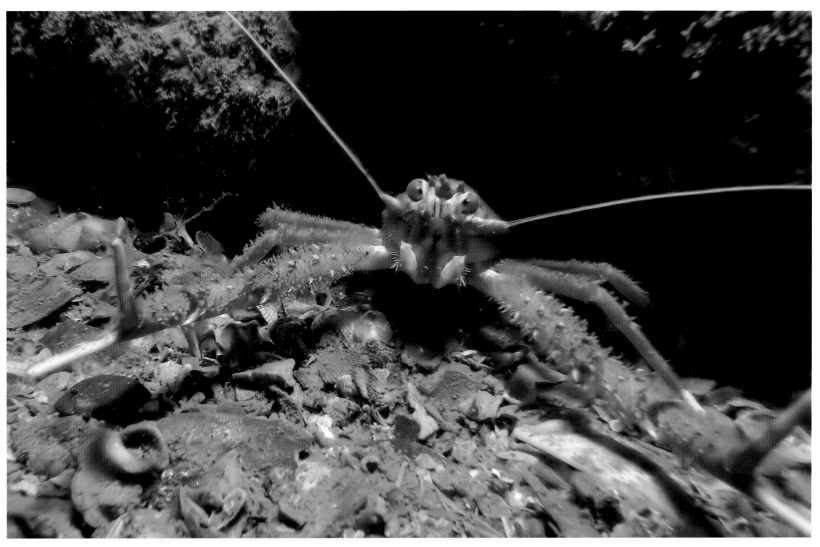

Long Clawed Squat Lobster (*Munida rugosa*). This is an abundant and easily photographed species as they tend to edge forward out of their shelter to investigate what's going on. (Lisa Whitfeld)

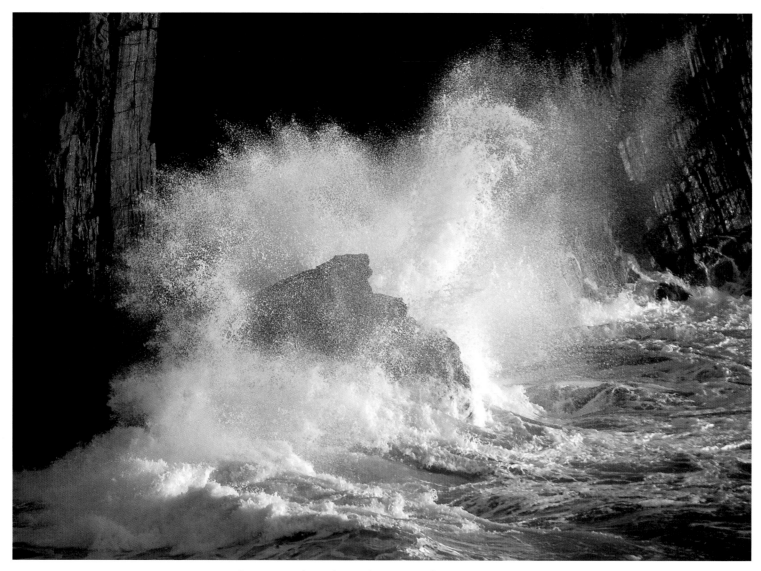

Breakers pounding the rocks at Caerfai. (Tony Rackham)

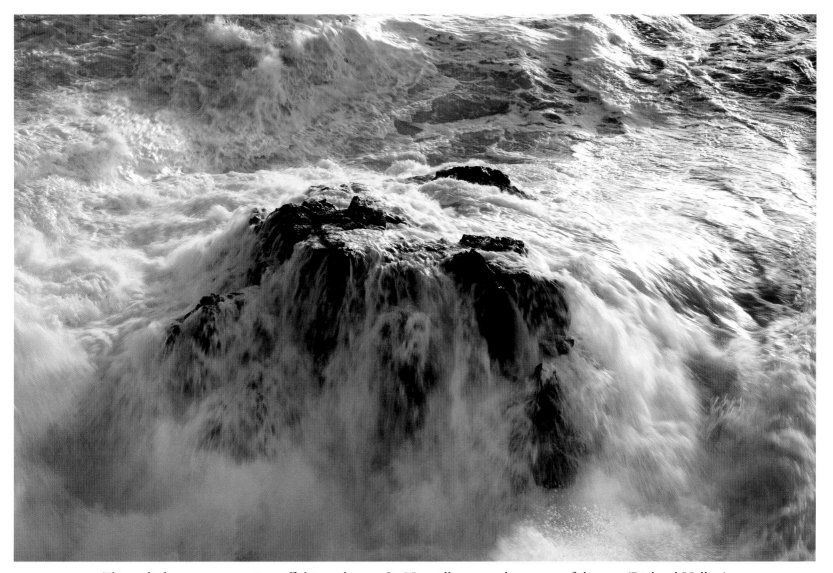

The turbulent water pouring off this rock near St. Nons illustrates the power of the sea. (Richard Hellon)

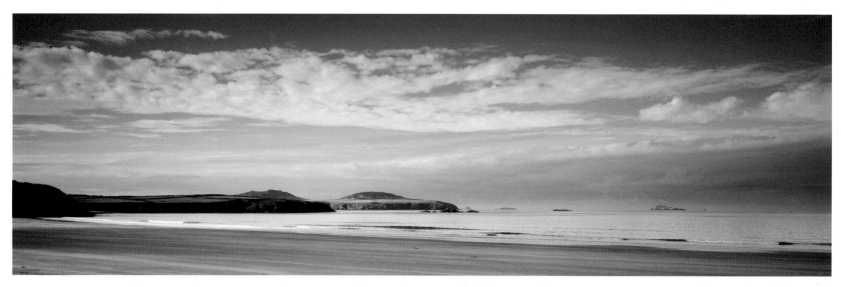

Whitesands Bay. (Adrian Hawke)

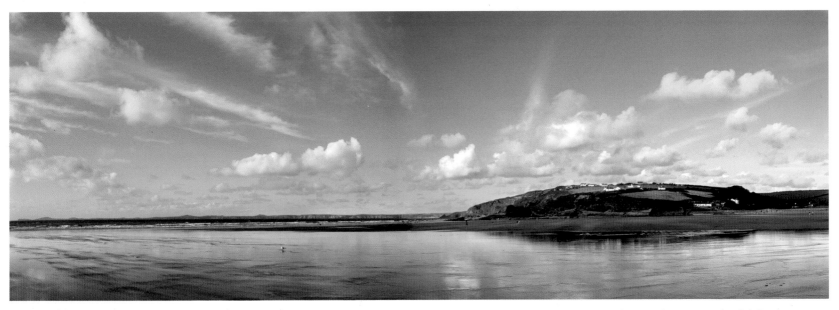

Broad Haven reflections. Under certain conditions the ebbing tide gives a glassy surface to the sand. (Lisa Whitfeld)

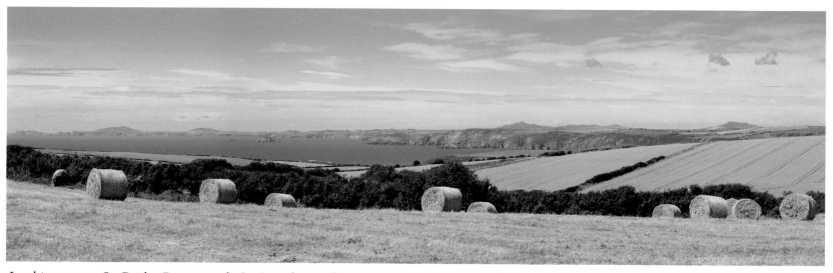

Looking across St. Brides Bay towards St. Davids Head. In the distance are the peaks of Carn Llidi and Carn Penberry. (Richard Hellon)

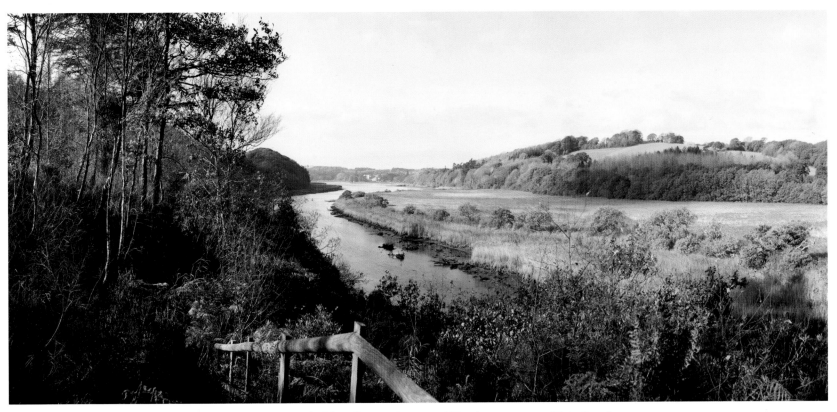

The eastern Cleddau from Minwear Wood viewpoint. (Eric Lees)

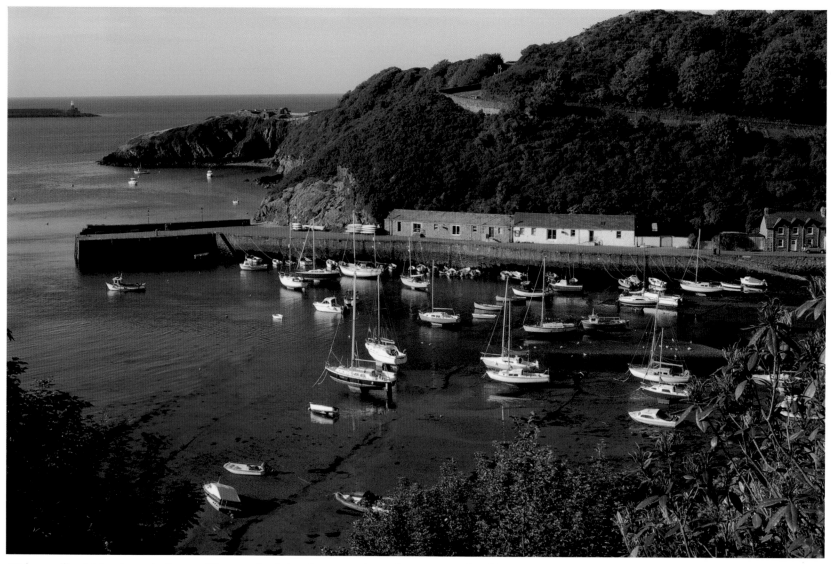

Fishguard's old harbour in Lower Town, which has been used as a location in the films *Moby Dick* and *Under Milk Wood*. (Tony Rackham)

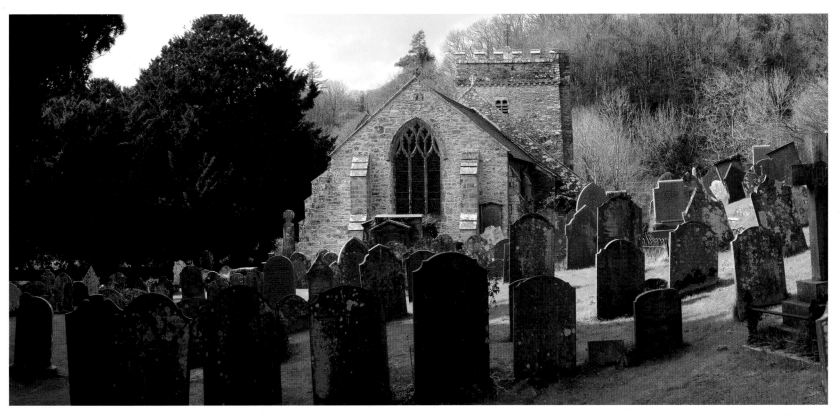

The Parish Church of St. Brynach in the tiny village of Nevern near Newport contains a large and impressive late 10th- or early 11th-century stone Celtic Cross. The church is said to have been originally founded in the 6th century and substantially rebuilt in the 15th with later additions in the 19th century. (Eric Lees)

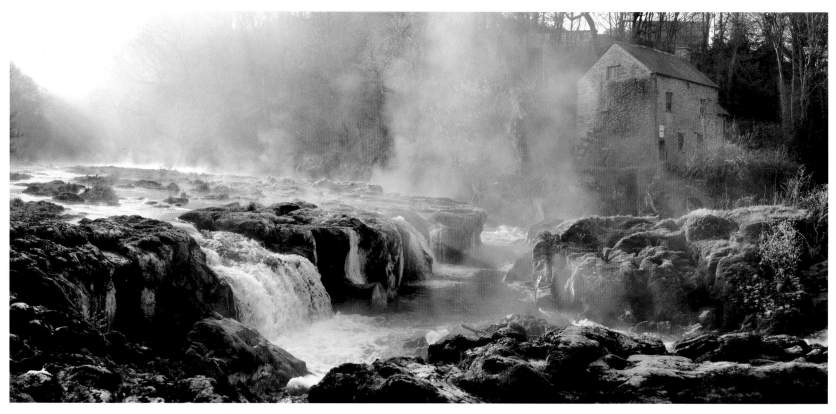

Salmon Leap at Cenarth on the Afon Teifi where the river produces a spectacular series of waterfalls. (Eric Lees)

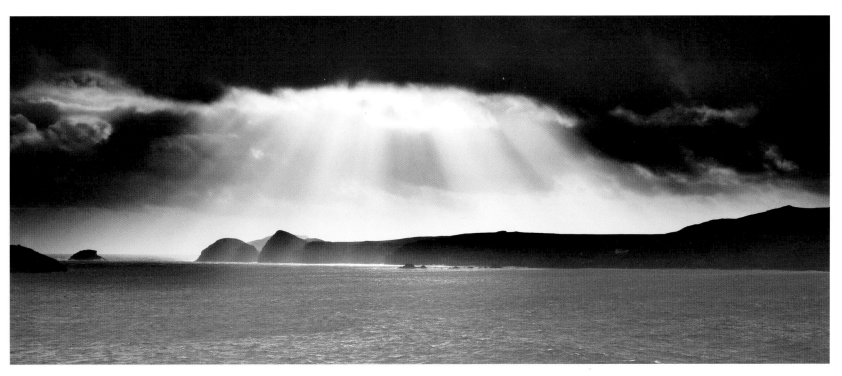

Sun, shower and wind, Ramsey Island. (Adrian Hawke)

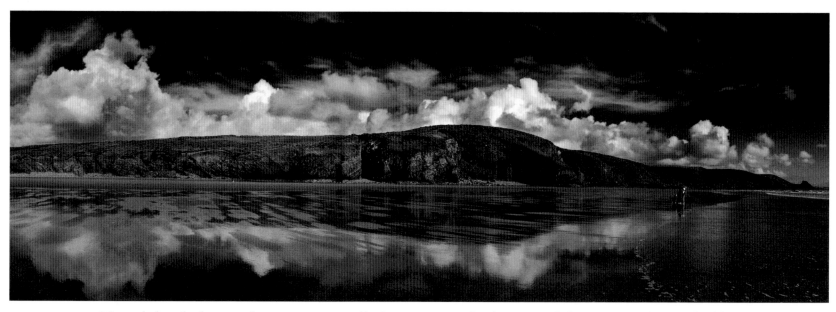

Newgale beach changes character as you walk along its two miles, but never fails to inspire. (Lisa Whitfeld)

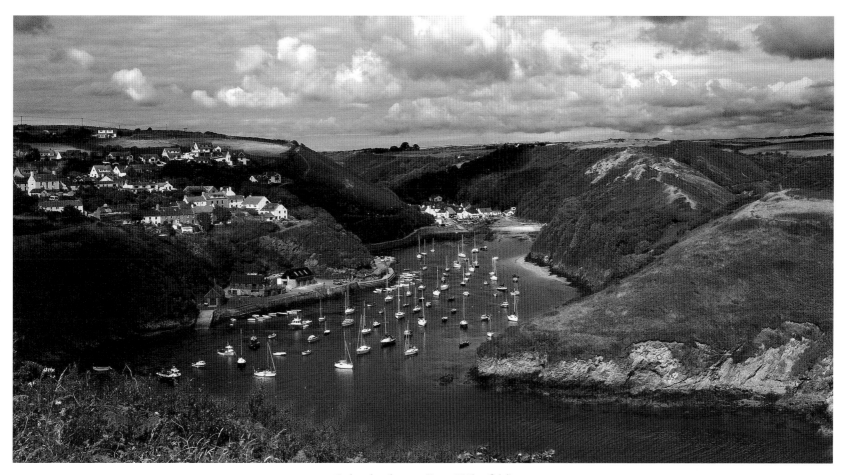

Solva harbour. (Lisa Whitfeld)

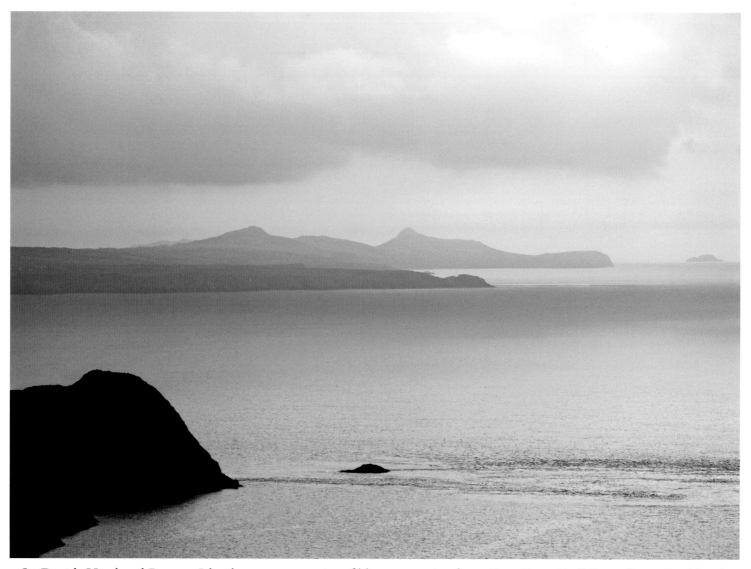

St. Davids Head and Ramsey Island appear as a series of blue mountains from Garn Fawr, Pwll Deri. (Betty Rackham)

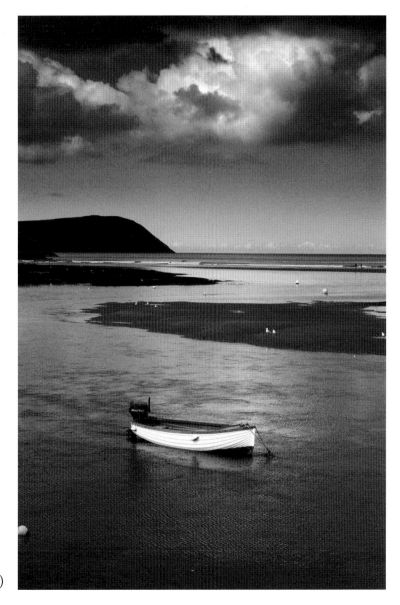

Newport beach. (Adrian Hawke)

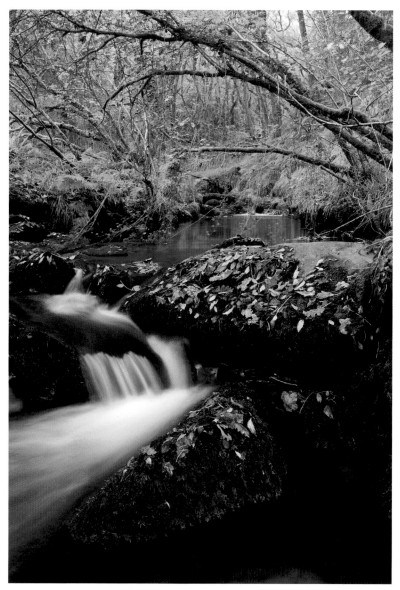

Gwaun Valley. It may look as if some leaves have been judiciously placed in these two photographs to enhance the composition but in fact the leaves are as they were when stranded by stream water. (John Archer-Thomson)

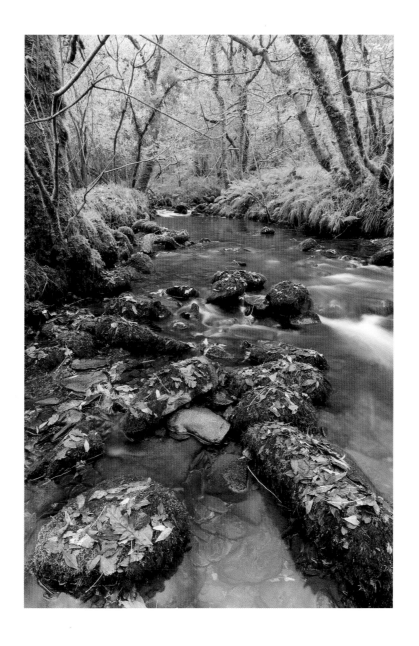

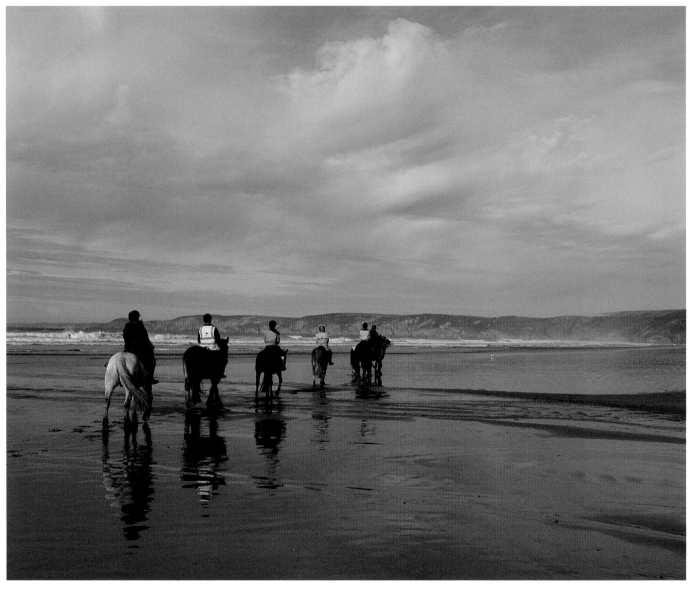

At low water, especially during spring tides, Newgale beach provides an immense expanse of sand which many people enjoy in a great variety of ways. Horse riders vie with walkers, photographers, sandcastle builders and sand-yachters to mention a few, whilst the sea invites swimmers, surfers, kite-surfers, body boarders and even paddlers! (John Archer-Thomson)

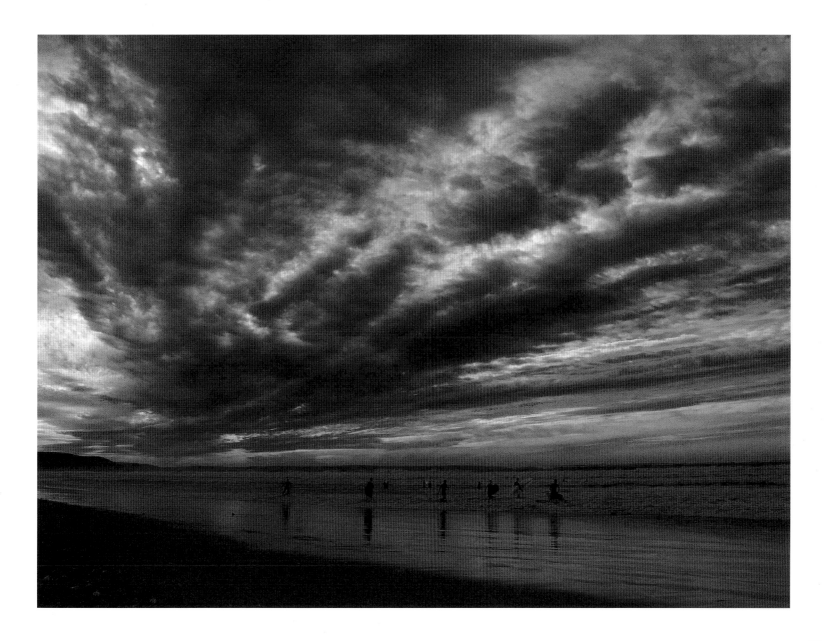

Tenby (this page and opposite) may have started life as an 8th-century Norse settlement but in the 9th century it was a Welsh stronghold. In the 12th it gained a Norman castle followed in the 13th by its famous town walls. The harbour's breakwater was built in 1328 and is reputed to be the first in Wales. (John Archer-Thomson)

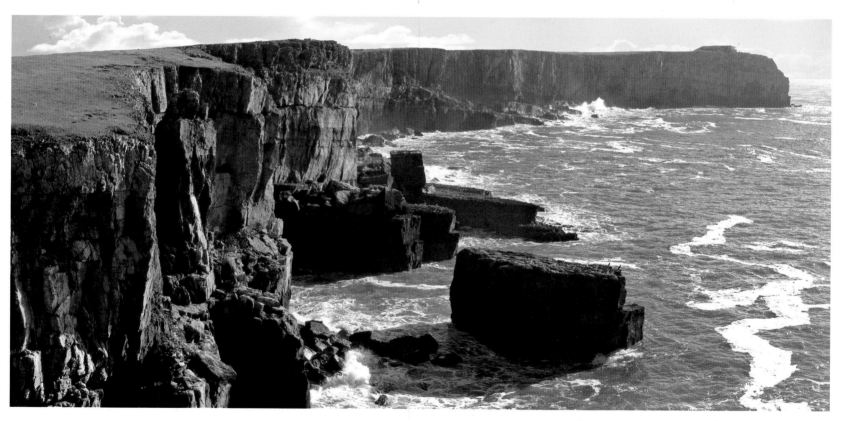

St. Govans Head. (Eric Lees)

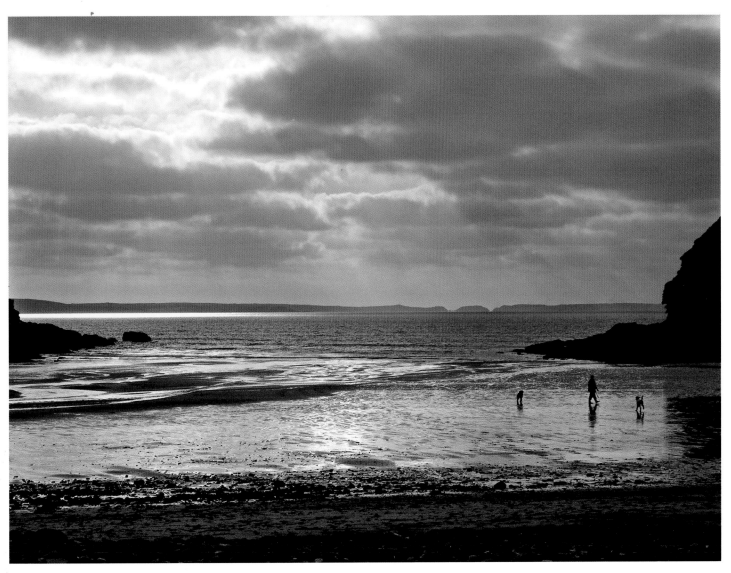

Nolton Haven. (Betty Rackham)

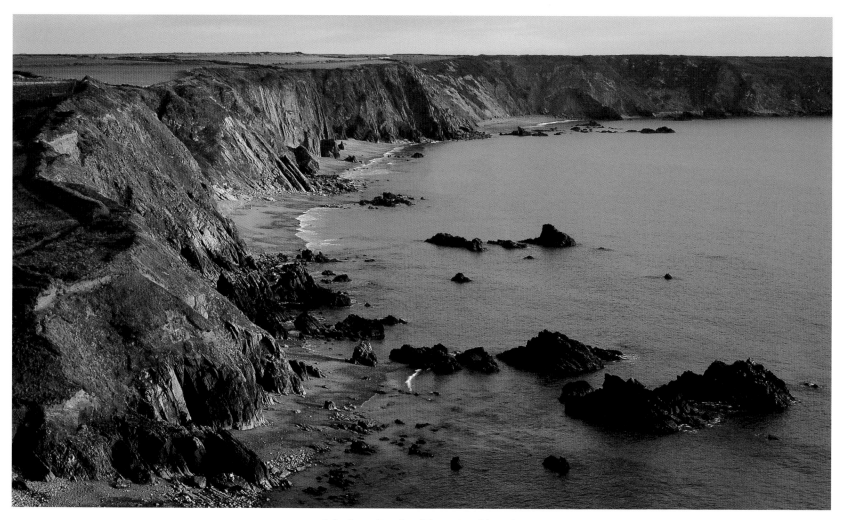

Marloes Sands. (Tony Rackham)

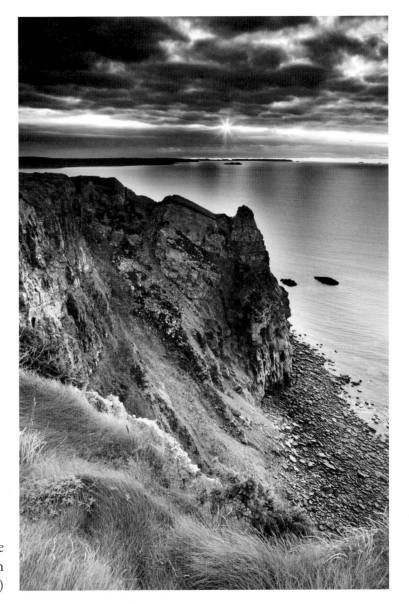

A view from Haroldston Chins across the south end of St. Brides Bay, with the sun sinking above Skomer. (Adrian Hawke)

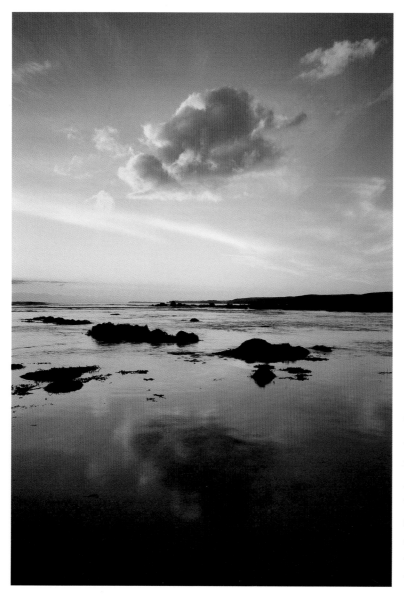

Freshwater West is another classic Pembrokeshire beach; it has recently been used as a location in the final Harry Potter film and also for another take on the life of Robin Hood and his merry men. This image shows a pool of water that was slowly expanding as the tide flooded the area; conditions were virtually windless so the calm water was able to reflect the colours on the underside of the clouds as the sun approached the horizon. (John Archer-Thomson)

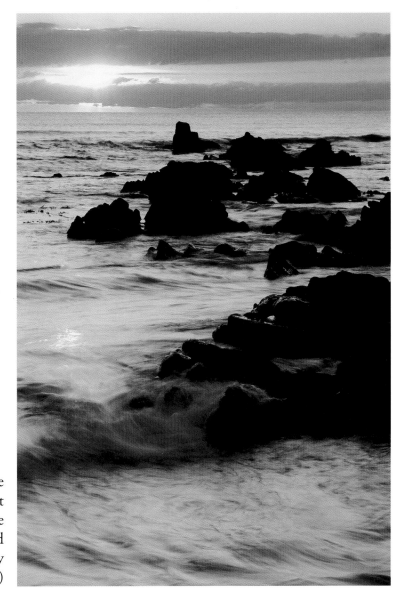

Freshwater West a little later on. As the tide reached the top of the beach, light levels were low enough to render the rocks as silhouettes. A slow shutter speed has allowed the water to appear slightly blurred. (John Archer-Thomson)

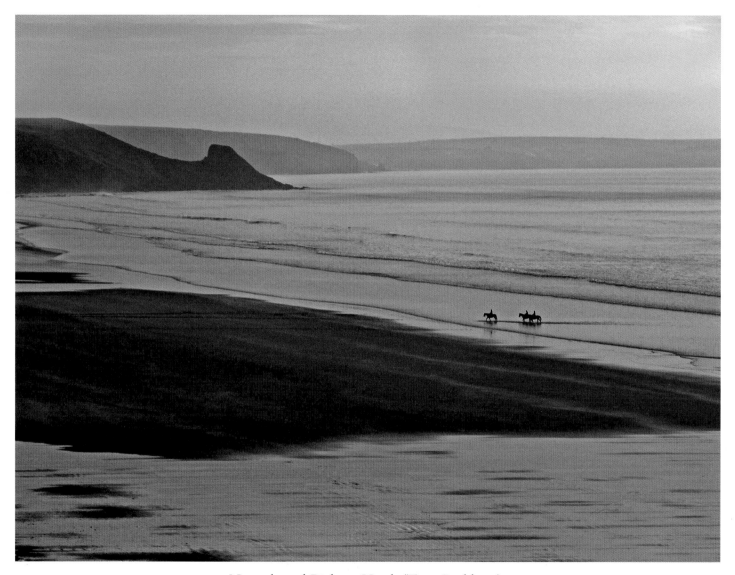

Newgale and Ricketts Head. (Tony Rackham)

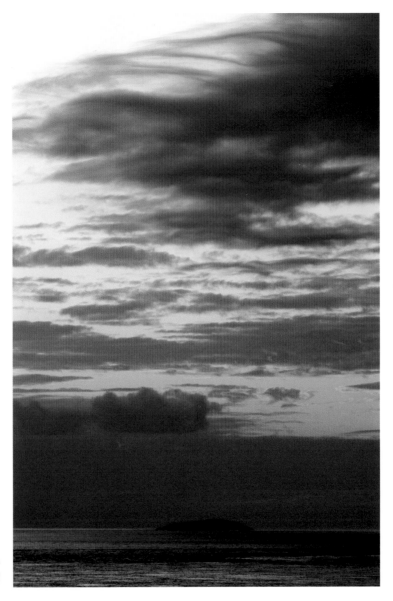

Looking towards Grassholm.
(John Archer-Thomson)

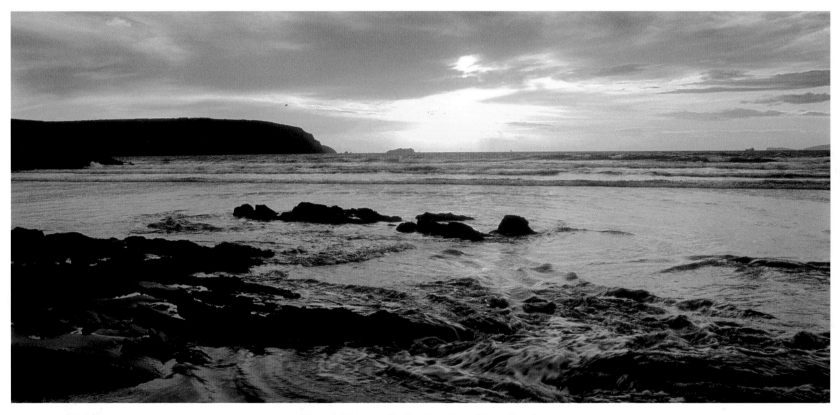

Broad Haven, St. Brides Bay. (Eric Lees)

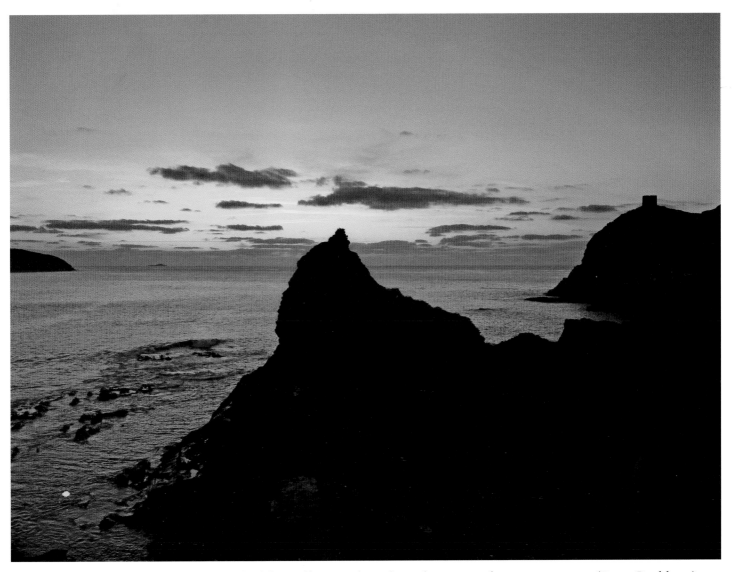

Sunset over Abereiddi beach. The building silhouetted on the right was an observation tower. (Betty Rackham)

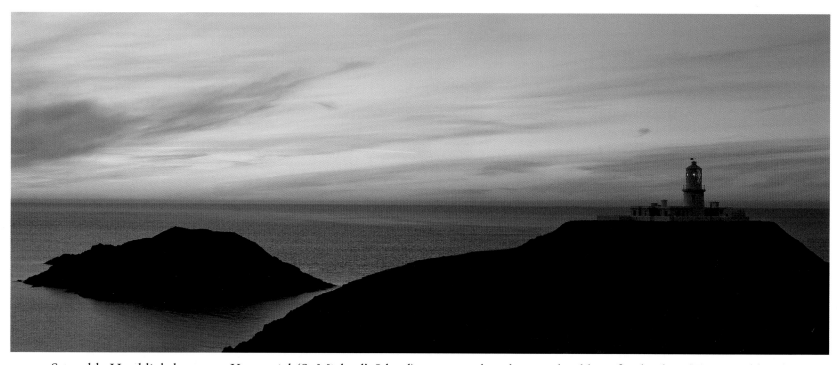
Strumble Head lighthouse on Ynysmeicl (St Michael's Island), connected to the mainland by a footbridge. (Tony Rackham)

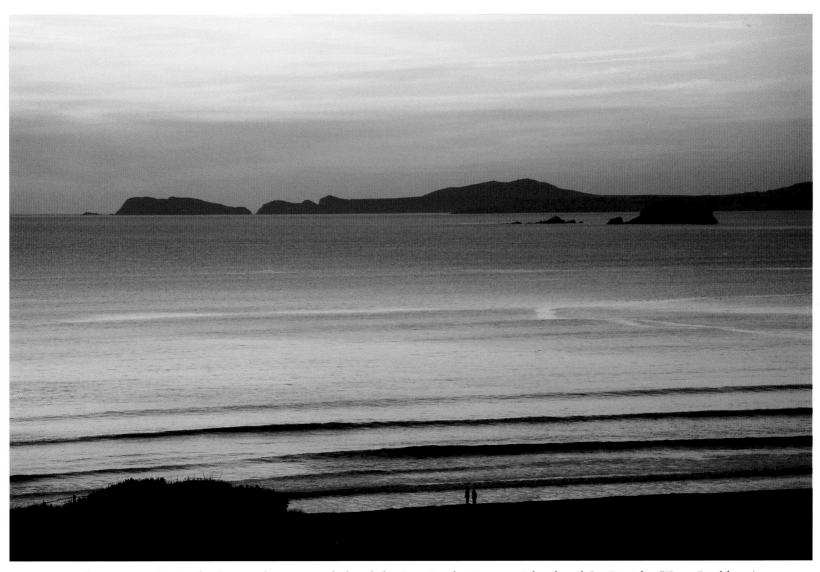

Looking across St. Brides Bay as the sun sets behind the Scar Rocks, Ramsey Island and St. Davids. (Tony Rackham)

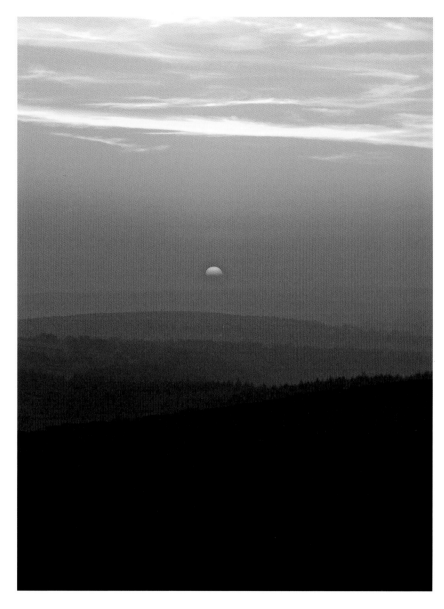

Sunset from Mynydd Cilciffeth. Ramsey Island and St. Davids Head gradually disappear as the sun sets behind them and mists rise in the valleys. (Betty Rackham)

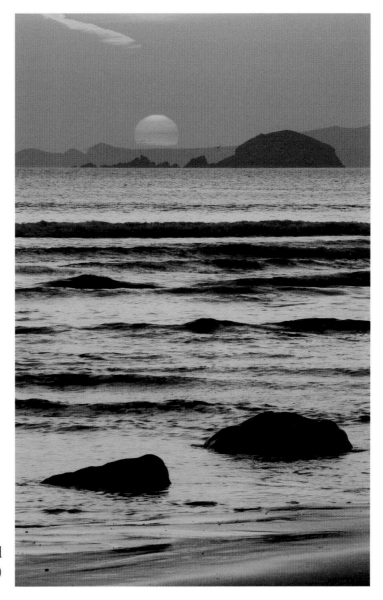

The sun about to disappear behind
St. Davids Head. (John Archer-Thomson)

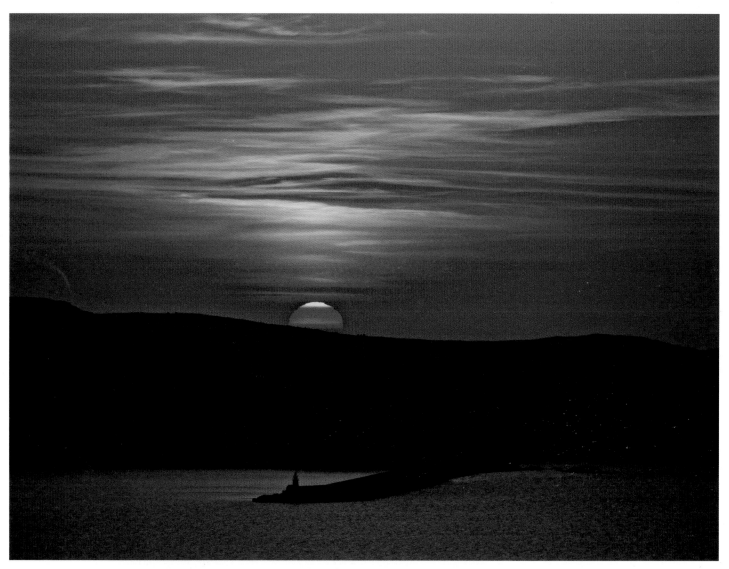

The sun sets behind the harbour and ferry terminal at Goodwick. (Betty Rackham)

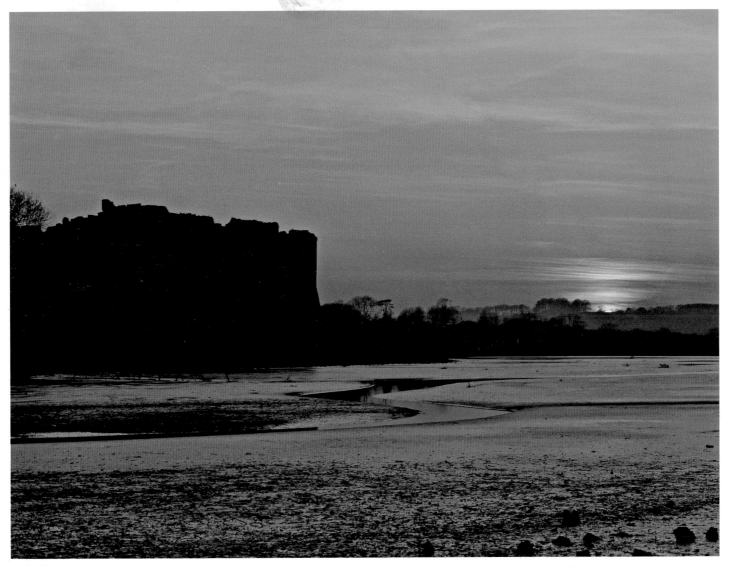

A blood-red sunset lights up Carew Castle and the Mill Pond. (Betty Rackham)

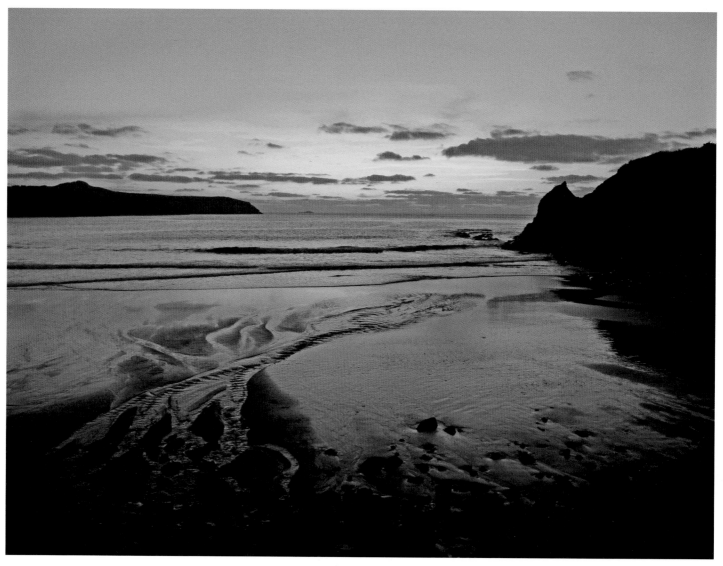

The sun sets at Abereiddi between Trwyncastell on the right and St. Davids Head and the North Bishop rocks. (Tony Rackham)

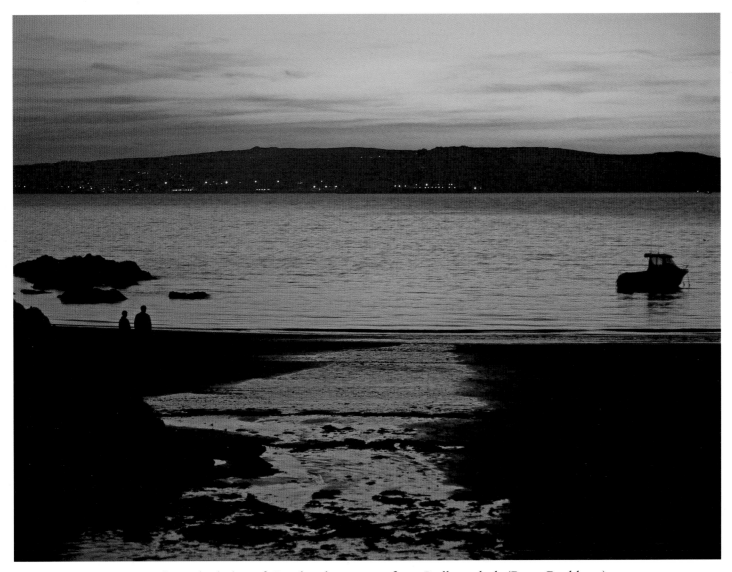

Watching the lights of Goodwick come on from Pwllgwaelod. (Betty Rackham)

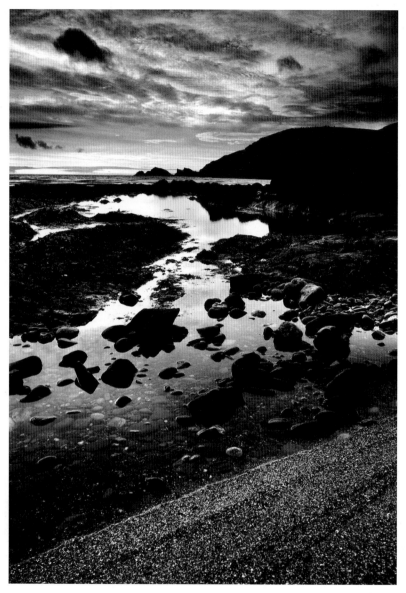

Grainy textures of the sand blend into rock pool reflections, encircled by the distant promontory of Pointz Castle, Penycwm, as the sun sets. Pointz Castle itself is believed to have been built in the late 12th century by a man named Pons, tenant of the Bishop of St. Davids. It was located roughly 2 miles south-east of Solva, and subsequently hidden behind the buildings of Pointz Castle farm. (Adrian Hawke)

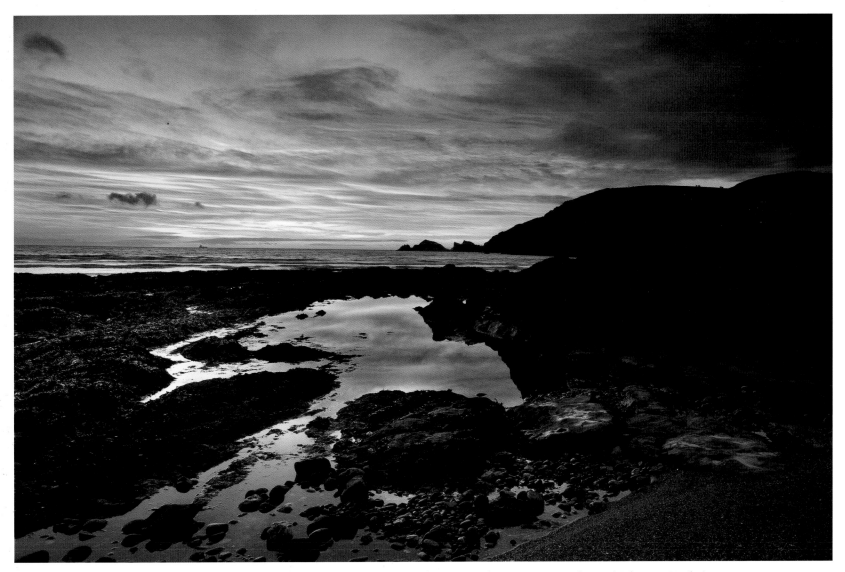

Fiery sky, Pointz Castle — one of the most vivid sunsets I have seen anywhere. (Adrian Hawke)

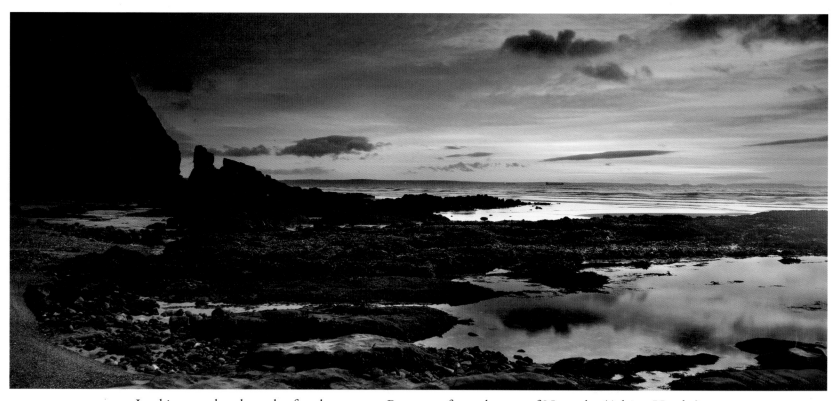

Looking south, a branch of rock separates Penycwm from the rest of Newgale. (Adrian Hawke)

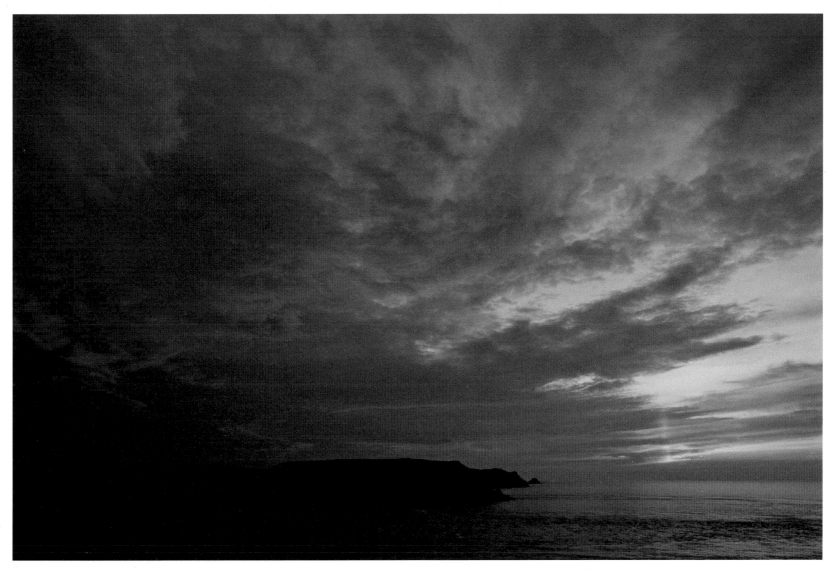

Sunset over Skomer as seen from Wooltack Point. (John Archer-Thomson)

The Photographers

John and Sally Archer-Thomson are a husband and wife team specialising in landscape and natural history photography. With a background and training in natural history and coastal ecology they have been photographing the landscapes, flora, fauna and underwater life of Pembrokeshire for over twenty years. They have a picture library (film and digital) of over 15,000 images including material from their overseas travels. They can be contacted via email: jhsat@hotmail.com, or www.natural-inspiration.co.uk.

Dr Toby Driver FSA joined the Royal Commission in 1995 assuming responsibility for the reconnaissance programme in 1997. A former chairman of the Aerial Archaeology Research Group, he was awarded his doctorate in 2006 following a study of the Iron Age hillforts of Ceredigion. His book *Pembrokeshire: Historic Landscapes from the Air* was published by the Royal Commission in 2007. Find out more about the Royal Commission at: www.rcahmw.gov.uk.

Adrian Hawke's fine art landscapes have grown out of nearly twenty years of experience and illustrate how he sees Pembrokeshire. He aims to create images which stir emotions or memories and encapsulate mood and feeling. Different techniques are employed, but perhaps most important is timing; timing of light, seasons, weather and tide. This knowledge allows him to produce resonant images that make him one of Pembrokeshire's leading landscape photographers. (Phone: 07779531426; www.Adrianhawke.co.uk).

After retiring from a career in medical science, **Richard Hello**n moved to Pembrokeshire twenty-one years ago but only started taking photography seriously over the last eleven years. He enjoys a wide variety of subjects, from landscapes through architecture to close-ups of flowers, lichens and rocks. The discipline of photography has served to increase his appreciation of the natural world.

His work can be seen on his web site (www.richardhellon.com). For further contact: richardhellon@aol.com or 01437 721168.

The ability to capture the simple majesty and beauty of Pembrokeshire in its natural state is the hallmark of **Eric Lees**' work. Early morning starts and evening trips from his home in Cilgerran ensure he shows the landscape in all its garments and through each season, bringing out the essence of the unique spirit inherent in this land and coastline.

After retiring as Head of Photography in a big F.E. college, **Betty Rackham** FRPS was glad to escape to Pembrokeshire and have time for her own work. She has always been fascinated by the way light and shadow can alter colours and enhance atmosphere. Pembrokeshire's varied landscape and constantly changing clear light means there is always something to photograph. (Phone: 01239 820068 or 01794 368498; www.bettony.co.uk)

Tony Rackham FRPS obtained a fellowship of the Royal Photographic Society in 1986 and his work has been accepted in many open exhibitions. The images he produces seek to capture the beauty of natural subjects such as plants, animals and unspoilt landscapes. He finds Pembrokeshire a constant source of inspiration with its rich wildlife, its rugged coast and gentle mountains, its ever-changing weather and its beautiful light. (Contact as above)

Lisa Gabrielle Whitfeld's portfolio includes local seashore abstracts, striking black and whites and colour panoramas of Pembrokeshire's stunning scenery, and underwater photography with images taken locally around Skomer as well as further afield. Lisa produces her images as prints or on canvas. She runs a Gallery and Framing Service called Celtic Images (www.celticimages.co.uk).